Sterling Clark in China

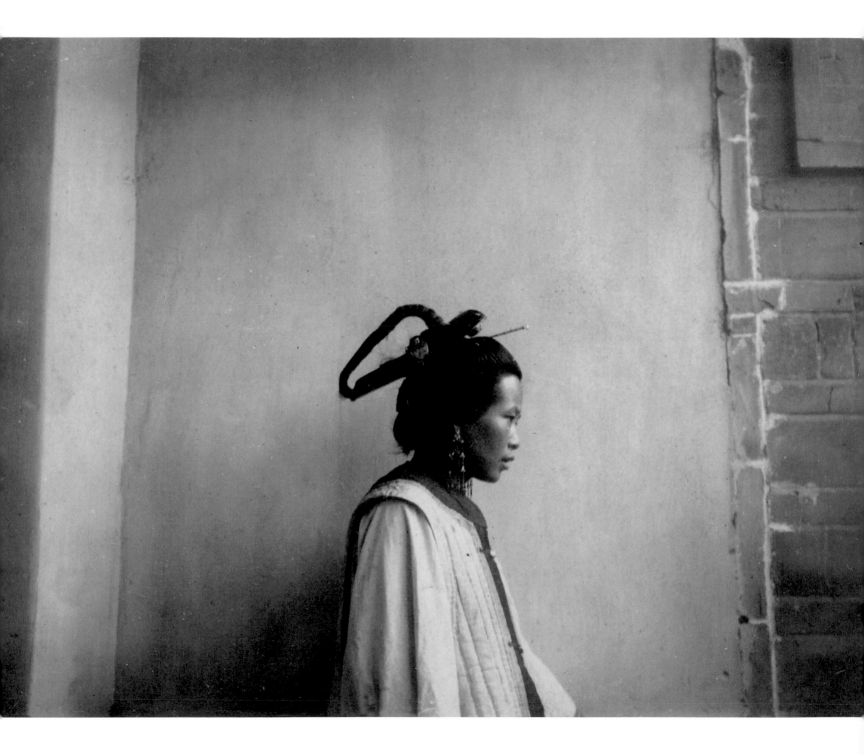

Sterling Clark in China

Thomas J. Loughman
With contributions by Shi Hongshuai,
Li Ju, and Mark Dion

Sterling and Francine Clark Art Institute
Williamstown, Massachusetts

Distributed by Yale University Press
New Haven and London

This book is published on the one hundredth anniversary of the publication of *Through Shên-kan: The Account of the Clark Expedition in North China, 1908–9*, and in conjunction with the following exhibitions:

Phantoms of the Clark Expedition: An Installation by Mark Dion
The Explorers Club
New York, New York
9 May–3 August 2012

Through Shên-kan: Sterling Clark in China
Sterling and Francine Clark Art Institute
Williamstown, Massachusetts
16 June–16 September 2012

Then and Now: Photographs of Northern China
Sterling and Francine Clark Art Institute
Williamstown, Massachusetts
16 June–16 September 2012

Unearthed: Recent Archaeological Discoveries from Northern China
Sterling and Francine Clark Art Institute
Williamstown, Massachusetts
16 June–21 October 2012

These exhibitions were organized by the Sterling and Francine Clark Art Institute. *Unearthed* was organized in association with Art Exhibitions China and is supported by the E. Rhodes and Leona B. Carpenter Foundation and the National Endowment for the Arts. *Through Shên-kan* is supported by the Fernleigh Foundation. *Phantoms of the Clark Expedition* and its interpretation are supported by the Fernleigh Foundation and by David Rodgers.

Produced by the Sterling and Francine Clark Art Institute,
225 South Street, Williamstown, Massachusetts 01267
www.clarkart.edu

Curtis R. Scott, Director of Publishing and Information Resources
Anne Roecklein, Managing Editor
Sarah Hammond, Special Projects Assistant

Designed by David Edge
Printed by SPC Macrom Studio, North Springfield, Vermont
Front cover illustration: View of the Great Wall showing encroaching sands near Yulin, Shaanxi province, November 1908 (plate 14 from *Through Shên-kan*)
Back cover illustration: Members of the Clark expedition at Yulin, Shaanxi province, December 1908 (*from left to right:* Sowerby, Clark, Cobb, Grant, Douglas)
Frontispiece: Woman with headdress in Zhenyuan Xian, Gansu province, summer 1909 (plate 44 from *Through Shên-kan*)

Distributed by Yale University Press, New Haven and London,
P.O. Box 209040, New Haven, Connecticut 06520-9040
www.yalebooks.com/art

Printed and bound in the United States of America
10 9 8 7 6 5 4 3 2 1

Library of Congress Cataloging-in-Publication Data

Loughman, Thomas J.
 Sterling Clark in China / Thomas J. Loughman ; with contributions by Shi Hongshuai, Li Ju, and Mark Dion.
 pages cm
 This book is published on the one hundredth anniversary of the publication of *Through Shên-kan: The Account of the Clark Expedition in North China, 1908–9*, and in conjunction with the following exhibitions: *Phantoms of the Clark Expedition: An Installation by Mark Dion,* The Explorers Club, New York, New York, 9 May–3 August, 2012, *Through Shên-kan: Sterling Clark in China,* Sterling and Francine Clark Art Institute, Williamstown, Massachusetts, 16 June–16 September, 2012, *Then and Now: Photographs of Northern China,* Sterling and Francine Clark Art Institute, Williamstown, Massachusetts, 16 June–16 September, 2012, *Unearthed: Recent Archaeological Discoveries from Northern China,* Sterling and Francine Clark Art Institute, Williamstown, Massachusetts, 16 June–21 October, 2012.
 ISBN 978-1-935998-08-2 (clark pbk. : alk. paper) — ISBN 978-0-300-17968-2 (yale pbk. : alk. paper) 1. Clark, Robert Sterling, 1877–1956—Travel—China. 2. China—Description and travel. I. Title.
 DS710.L86 2012
 915.104'35—dc23
 2012024994

Contents

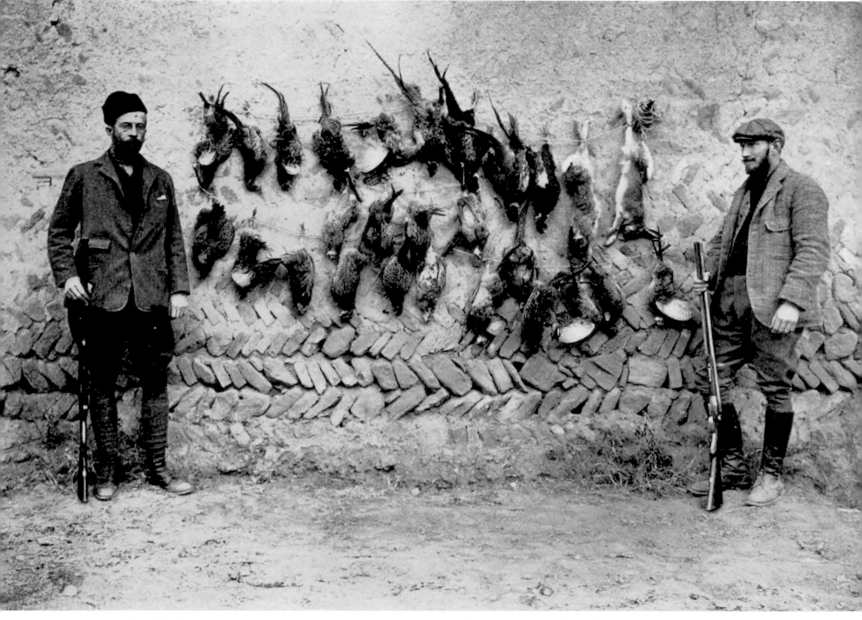

Robert Sterling Clark *(left)* and Arthur de Carle Sowerby *(right)* with Christmas Day's bag of pheasants, near Yulin, 1908 (plate 21 from *Through Shên-kan*)

Director's Foreword

Of the many projects I oversee as Director of the Clark, none are more rewarding than those documenting our institutional history, projects that at the same time address the biographical research that contextualizes that history. The monumental exhibition and catalogue *The Clark Brothers Collect* (2005) probed the Clark family dynamics as well as the collecting achievements of Sterling and Stephen Clark that resulted in their extraordinary contributions to the establishment of this country's art institutions. Our decision to investigate Sterling Clark's engagement with China had a similar aim of contributing to that history and biography—the results of which we could never have anticipated, results that have been energizing to everyone involved in this multifaceted study.

In 2007 when we launched an initiative to commemorate the one hundredth anniversary of Sterling Clark's expedition to northern China, our ambition was circumscribed by the fact that we knew little of Clark's activity there other than what he documented in his book published in 1912, *Through Shên-kan: The Account of the Clark Expedition in North China, 1908–9*. In spite of this limitation, our efforts have been broad, investigative, and celebratory. This initiative has resulted in programs ranging from the donation in 2008 of original copies of *Through Shên-kan* to officials in Xi'an, Lanzhou, and Taiyuan (the capitals of three of the northern China provinces explored by Clark) to this year's organization of *Unearthed: Recent Archaeological Discoveries from Northern China*, the first archaeological exhibition in the Institute's history. Our efforts have also catalyzed photographers, filmmakers, and historians in China to contribute. Among the Chinese-initiated projects are a critical translation of *Through Shên-kan* undertaken by Professor Shi Hongshuai, a specialist in historical geography at Shaanxi Normal University, Xi'an; a four-part television series on the expedition aired on CCTV in 2010; and the work of photographer Li Ju, who journeyed many times across *Shên-kan* to document the terrain and monuments encountered by the expedition and to create contemporary images of the exact sites photographed by the Clark expedition team one hundred years earlier.

The exhibition *Through Shên-kan: Sterling Clark in China* and this catalogue summarize the accomplishments and impact of Sterling Clark's 1908–9 expedition, benefiting from the historical perspective that only a century's distance can provide. Many of the expedition's surveying and other instruments on view were carefully kept by Clark throughout his life. We have discovered through our research that specimens and additional materials related to the expedition found their way to the Smithsonian Institution through Arthur de Carle Sowerby, the naturalist Clark engaged for the trek and continued to support throughout his life. These natural history specimens inform and animate both this exhibition and our understanding of the impact of the expedition on the study of the botany, geology, weather, and mammal and bird life of northern China.

This catalogue benefits from diverse perspectives on the Clark expedition and its legacy. It includes a critical assessment of the expedition within the context of late nineteenth- and early twentieth-century Western exploration in northern China by Professor Shi Hongshuai. In *Then and Now: Photographs of Northern China*, Li Ju pairs images from the Clark expedition with his contemporary views of the same locations, documenting the extraordinary ways in which the country has changed and also remained the same over the course of a century. *Phantoms of the Clark Expedition* is an installation at The Explorers Club in New York, in which the artist Mark Dion examines the themes of exploration and discovery through a series of dioramas and papier-mâché sculptures reminiscent of the tools and specimens associated with early scientific expeditions.

I wish to thank the Fernleigh Foundation for their generous support of these projects. I also extend our thanks to the Williams College Archives and Special Collections, the United States Army Military History Institute Library, Harvard University, and especially to our colleagues in Washington, D.C., at the Smithsonian Institution Archives and the National Museum of Natural History who have hosted our researchers and lent generously to the exhibition.

Michael Conforti, Director

ROUTE OF THE CLARK EXPEDITION
THROUGH SHANSI, SHENSI, AND KANSU.
1908-9.

Reduced from Plane table Survey by Hazrat Ali, Survey of India.

Scale 1 inch or 1.014 Inches to 16 Miles

Meanings of some common place name terminations

LAN-CHOU FU

CHING YANG FU

NU-YUAN CHOU

CHEN-YUAN HSIEN

CHING NING CHOU

AN-TING HSIEN

K A N S U

Sterling Clark in China:
Inspirations and Legacies

Thomas J. Loughman

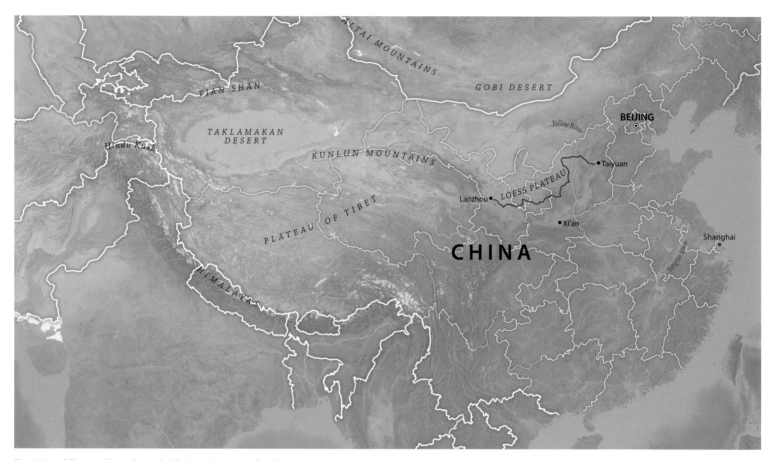

Fig. 1 Map of China; red line indicates the Clark expedition route from Taiyuan to Lanzhou

Robert Sterling Clark (1877–1956) organized and led an ambitious scientific expedition through northwestern China in 1908–9 (fig. 1). That he did this may at first seem curious since he is known principally as an art collector and thoroughbred horse owner. Indeed, he is a personality both familiar and mysterious to many, the curious result of the complexities of his story and character. The Sterling and Francine Clark Art Institute has worked with many interested historians, biographers, and colleagues to understand his family and background, those passionate pursuits of art collecting and horse breeding, and the details that led him to found the Institute and ensure its realization in Williamstown. Yet there remains a period in his early adult life that invites deeper investigation: his first decade as an adult, after his graduation from Yale in 1899 through

the time he settled into a genteel life in Paris in 1910. In these years, Sterling Clark lived far from his roots in midtown Manhattan and Cooperstown and accomplished more as a soldier and explorer than most people—even those of his exceptional means and education—ever do.

Now, on the occasion of the centennial of the publication documenting his scientific exploration through four Chinese provinces, *Through Shên-kan: The Account of the Clark Expedition in North China, 1908–9* (fig. 2), there is an opportunity to further examine this critical moment in his biography and to scrutinize his motivation and activity as, for lack of a better term, an adventurer. In recovering Sterling Clark's story at a distance of more than one hundred years, the nuances of these ambitious and successful endeavors reveal

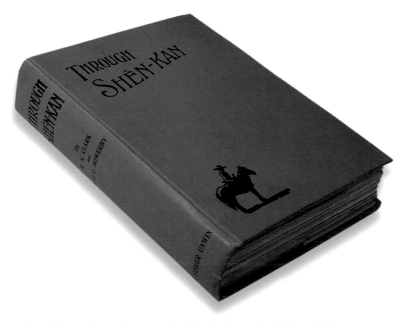

Fig. 2 *Through Shên-kan: The Account of the Clark Expedition in North China, 1908–9*

fundamentally different aspects of him than those previously known or imagined. What at first blush may have seemed in the past as the fanciful activity of a wealthy dilettante can be appreciated today as a significant and inspiring contribution to learning—outsized in its scope and accomplishment even for its day—and the beginning of a career diverted by the tumult of major world events.

This essay examines Sterling Clark's expedition through the lens of his choices and experiences from the turn of the century through the contemporary legacy of his scientific campaign in China. It is not intended to be the definitive guide to contextualizing the expedition's place in the history of American and international science and exploration—a topic Professor Shi Hongshuai's essay in this volume addresses squarely. Rather, this essay surveys the facts and circumstances that led him to mount the expedition, the expedition's scope, reaction to the findings published in *Through Shên-kan*, and Clark's continuing support of biological field work begun during the expedition and pursued by the naturalist Arthur de Carle Sowerby through the first half of the twentieth century. What motivated Sterling Clark to organize and lead a scientific endeavor halfway around the globe? What role did he play, and how

did he prepare for such an undertaking? Much of the scientific material gathered on the trek has been held in public collections, and Clark's rich personal archives and those of the Smithsonian Institute have been invaluable tools for linking and building historical meaning out of what could have been mistaken for random and unconnected events. Now, these materials enable us to see and measure an intriguing and stimulating episode from the opening years of the twentieth century that just happens to have the Clark Art Institute's founder and the aspiring young naturalist Arthur de Carle Sowerby as its main protagonists.

Science in the Family

While Sterling Clark's first interest in science and the collecting of specimens is unknown, he may have been inspired by the example of his grandfather Edward Clark (1811–1882). Having made a fortune as a founding partner of the Singer sewing machine company, Edward Clark reconnected in the late 1870s with his alma mater, Williams College, from which he graduated in 1831, and soon became an important benefactor and trustee. As stated in his Williams Alumni obituary, "he became Trustee in 1878 and brought to the college the same business sagacity that he had displayed in his own affairs."[1] It can rightly be said that Edward Clark was the most generous sponsor of the sciences in the college's first century.

The Reverend Paul A. Chadbourne (1823–1883), who joined the Williams College faculty in the 1850s and served as college president in the 1870s, taught natural science and accompanied the student group known as the Lyceum of Natural History on specimen collecting campaigns to the Bay of Fundy, Labrador and Greenland, Honduras, and Florida, continuing a tradition of such collecting trips dating back to the late 1830s. Shortly after becoming the college's president in 1872, Chadbourne expanded the college's curriculum, collections, and facilities in the natural sciences. Partly his own quest and partly a reasoned response of his institution to the increasingly common call within America's liberal arts colleges to embrace the currents of "modern" disciplines, Chadbourne appears to have made great strides. Simultaneously, the college was in financial straits, and Chadbourne's administration strove

Fig. 3 Wilder Cabinet of Geological Specimens, as displayed in 1903 in the original Clark Hall at Williams College, Williamstown, Mass.

Fig. 4 Commissioned from architect Henry J. Hardenbergh by Edward Clark, Clark Hall was completed and opened in 1882, Williams College, Williamstown, Mass.

to stabilize and inject new life into the institution. These curricular reforms and an aggressive approach to enhance the campus were key elements of his mandate to improve the college's profile and fortunes. At the annual meeting held in July 1876, he requested permission from the college's board of trustees to empower Sanborn Tenney, professor of natural science, to raise funds to construct a "proper hall for science" on the campus.[2] Previously, there were only two buildings that allowed the Williams community to engage in the study of the natural world: Hopkins Observatory (erected 1836–38) and Jackson Hall (erected 1855), an improvised home for the college's specimen collections.

As Chadbourne and Tenney were advancing the sciences at Williams, Edward Clark made a series of significant gifts that would give life to the sciences on campus. In the years following the Civil War, the Singer Manufacturing Company flourished and Clark began transforming the family's fortunes into substantial real estate holdings in Manhattan. His standing within the alumni as one of the college's most affluent and successful graduates may have aroused Chadbourne's attention just as the recent death of his wife, Caroline Jordan Clark, in 1874, may have refocused him on expanding his charitable works. In 1878 he donated funds to purchase a collection of mineralogical specimens, known as the "Wilder Cabinet," which had been assembled from around the

world by a collector from southern Vermont (fig. 3). In the years that followed, Edward Clark commissioned for the college a facility for this and other collections at great expense. He deeded the finished structure to Williams in 1882—just months before his death—and left a large cash bequest, "to the general fund . . . the princely sum of Fifty Thousand Dollars."[3]

Clark Hall (fig. 4) opened at the same time as the new Field Astronomical Observatory. Together, these buildings fundamentally recast the possibilities of natural science studies at Williams. Designed by the mid-Atlantic architect Henry J. Hardenbergh (1847–1918) in the same years he was designing the Dakota apartment building on Central Park West and a number of other apartment houses in New York City for Edward Clark, Clark Hall was sited alongside Jackson Hall and the old observatory on the shoulder of a hill at the east edge of campus. Its usable life ended in the first years of the twentieth century, when extreme weather and its unstable site combined to weaken it.[4] While the young Sterling Clark's early interaction with the building and its collections remains unknown, he (along with his mother and three siblings) helped fund a new structure, present-day Clark Hall, with a donation in the summer of 1907.[5]

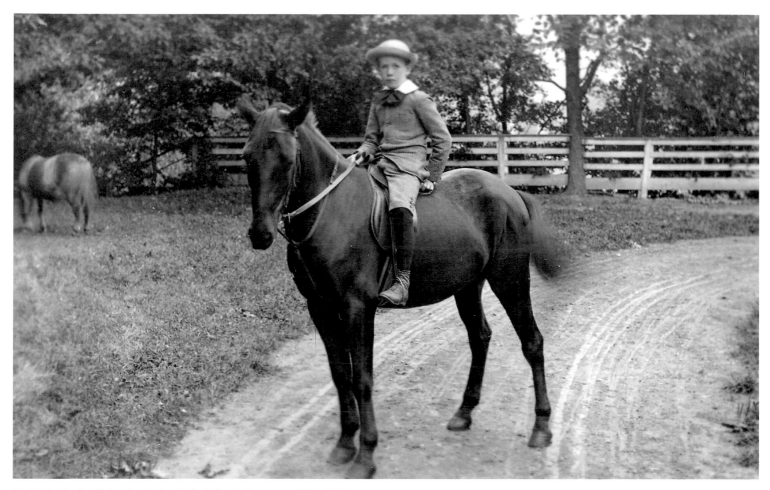

Fig. 5 Robert Sterling Clark on horseback at the family farm in Cooperstown, N.Y., c.1887

Early Life, Education, and Soldiering

Sterling Clark, known to his family as Robin through childhood, was just five years old when his grandfather donated Clark Hall to Williams. Born the second of four sons of Alfred and Elizabeth Clark, he attended Cutler's School in Manhattan and later enrolled at Yale University's Sheffield Scientific School, where he studied civil engineering. As he was growing up, his family split their time between their townhouse at 7 West 22nd Street in New York (the same house in which he was born on June 25, 1877) and summers at their farm in the verdant hills of Cooperstown, NY (fig. 5). One can imagine a boyhood filled with the urbane experiences of gilded-age New York mixed with the joys of country life, dramatically set within the very environment romanticized by James Fenimore Cooper's *Leatherstocking Tales*. While Clark left no specific evidence of youthful exploration, he displayed a lifelong passion for horses and the bucolic charms of country living that logically sprung from early patterns learned through his family. This pattern of city and summertime mountain retreats as a teen preceding entry into the Ivy League had been followed for over a generation by leading New Yorkers, most notably by fellow Culter's School alumnus Theodore Roosevelt, who famously spent his summers in suburban New Jersey and the Adirondacks exploring nature, collecting and preparing animal specimens, and publishing his amateur zoological findings. Like Roosevelt, Clark also lost his father when

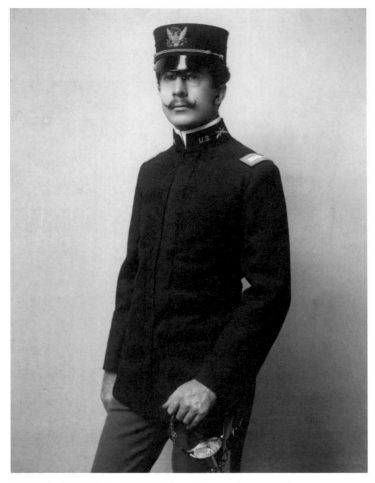

Fig. 6 Robert Sterling Clark in his Ninth Infantry Regiment uniform, c.1899

the command of Captain André W. Brewster.[7] The Philippines had come under American control at the end of the Spanish-American War in 1898, but it was a bitter prize—the indigenous people had long detested the Spanish colonizers and they resisted American authority as well. Clark reported for duty on 29 December and joined the company's encampment in the mountains northwest of Manila. His responsibilities were immediate: on 6 January 1900, he confiscated a Remington rifle from an insurgent while in temporary command of his company on the road between Tarlac and Capas.[8] Other than being sick for ten days in March and a brief leave to visit Manila, the jungle and the monotony of camp life defined Clark's world through the spring and early summer of 1900.

This new life for Clark as an army officer may seem like a curious choice, yet it was one shaped by both the infinite possibilities available to him and the allure of the gentleman soldier of his day. He inherited a series of lucrative rental properties and land in Manhattan from his grandfather in 1882 and his father Alfred's death in the spring of 1896 left him an additional fortune.[9] The exploits of the First U.S. Volunteer Cavalry (the "Rough Riders") in the Spanish-American War—its ranks populated in part by Ivy Leaguers and clubmen from New York—must have impressed him, particularly when its leader, Theodore Roosevelt, was elected governor in the autumn of 1898. As a young gentleman from Manhattan and Cooperstown fresh out of Yale, Sterling Clark fit in easily among his fellow officers in the Ninth Infantry Regiment as well as in the echelons of army leadership.

Yet Clark's elite background and exceptional means were no shield from the raw and dangerous realities of army life. In June 1900, Clark and the entire Ninth Infantry were mobilized as part of a multi-national force called the China Relief Expedition, sent to quell the Boxer Rebellion. Two ships transported the regiment and their gear to northern China via Nagasaki, Japan, where they rendezvoused in early July with the other foreign troops hastily assembled by the great military powers of Europe and Asia.[10] The Chinese government had permitted the Boxers, a group of nationalist guerillas eager to reject foreign participation in Chinese affairs, to hold all foreign diplomats, religious missionaries, and businesspeople captive in Beijing. The Boxers burned down the

he was just a teenager in his first year of college, and found himself highly educated, of means, and free to pursue a future of his own choosing.

It was a different and unlikely set of circumstances in the first five years of the twentieth century that seems to have had a catalyzing influence on Clark's decision to mount his expedition to China. The experiences and knowledge that he gained in these years both enabled him to conceive of such an outsized undertaking and provided his first exposure to Asia. After graduating from Yale in 1899 he received a commission as a second lieutenant in the Ninth Infantry Regiment of the U.S. Army (fig. 6);[6] by year's end he was on his way to the Philippines to join Company B under

foreign settlements, administrative offices, embassies, and trading houses in the capital and imperiled the fragile peace brokered between the unsteady empire and the industrialized powers. Galvanized in their will to reestablish their foothold in China, the governments of Japan, Germany, England, France, Italy, the Austro-Hungarian Empire, Russia, and the United States made the fateful decision to invade.

The allied forces landed on the coast just east of the city of Tianjin (then known as Tientsin) and initially proceeded inland without incident. Then on 12 July, a skirmish broke out between the seven thousand foreign troops and a force three times its size made up of Chinese Imperial troops and the Boxers. Battle consumed the following day as well. One in ten of the foreign troops were injured or killed, including Clark's regimental commander, Colonel Emerson Liscum. From Clark's own company of just over one hundred men, three died and ten were wounded. On a set of battlefield photographs Clark recalled the movements and emotions he experienced that day:

> We halted on road in foreground for the Japanese infantry to pass in double time.
> We, the officers walked along the footpath with men below in full view of Chinese some 1000 yds away.
> This was the exact position of "B" Co[mpany] 9th Inf[antry] where we kept under shelter all day long!!![11]

Clark's company commander, Captain Brewster, saved two men from drowning while under enemy fire—valiant acts for which he was awarded the Medal of Honor. Clark was also cited for his meritorious service during the Battle of Tientsin.[12]

Following the battle, Clark led his company to Beijing, experiencing only minor military resistance along the way. By mid-August, Clark and his men liberated the captive Americans in the area to the south of the Forbidden City and Tiananmen Square, where the foreign trade compounds and legations were located. The thousand-man force of the Ninth Infantry stayed on for nine months. As they left systematically in May 1901, the three officers and one hundred forty enlisted men of Company B assumed

special duty as U.S. Legation Guard through the end of 1904. Clark himself would lead Company B for the next year as the *de facto* second-in-command as the situation in Beijing stabilized.

Lieutenant Clark received orders on 12 July 1901 to leave his post in Beijing on 20 August and report for a special assignment three months later—a staff position at the War Department in Washington, D.C.[13] When he arrived he joined a team working within the Military Information Division for the Adjutant General of the Army, Henry Corbin. While Clark was in transit, President McKinley was assassinated by an anarchist in Buffalo while attending the Pan-American Exposition, and Theodore Roosevelt had been sworn in as president on 14 September. Roosevelt, like McKinley, recognized the rising profile of the American military among the major world powers. Clark's new assignment was with the new working group charged with collecting and summarizing information on the military capabilities and techniques of the great world powers. Clark would serve in that capacity for nearly two years, through the spring of 1903, engaged in work that would prepare him well for his future exploits as an explorer and systematic compiler of technical data. Most of the work involved reading published reports in foreign languages and writing brief summaries for an annual publication called *Notes of Military Interest*. Over the next year and a half he contributed several digests to *Notes* for the 1901 and 1902 editions, on subjects as wide-ranging as carrier pigeons and mechanical transportation.[14] Within a decade Clark would publish a similar work: a team-authored study summarizing the findings of a scientific expedition of his own design, the aforementioned book *Through Shên-kan*.

In Washington, the young lieutenant rented a fashionable townhouse at 1221 Connecticut Avenue (between the White House and Dupont Circle) and became a society fixture shortly after he arrived. On 9 December 1901, within three weeks of starting his new job, Clark attended a reception at the White House,[15] and within a few months rumors (refuted in the press) were circulating that he was engaged to Alice Roosevelt, the president's eighteen-year-old daughter.[16] In August 1902 he was promoted to first lieutenant and later in the summer he spent time with his family, escorting his mother at her wedding to Bishop Henry Codman Potter on 4

October in Cooperstown.[17] Back in Washington at year's end, he organized a cotillion for five hundred guests at the new Willard Hotel (the latest building completed by his family's favored architect, Henry J. Hardenbergh) on 22 December as "a gracious return for social courtesies extended to him."[18] Joined by his younger brother Ambrose and his sisters-in-law, Clark welcomed many of Washington's diplomatic, military, and political elites and offered each guest a small silver party favor—perhaps an indication of his preference to be called by his middle name, Sterling, and not Robert or "Robin" as his family called him during his boyhood years. It was rumored the party cost $10,000.[19] Afterwards, invitations for social events continued to come from the likes of Senator Joseph Foraker (a powerful Ohio Republican) and the family of Army Paymaster General, John Bates.[20]

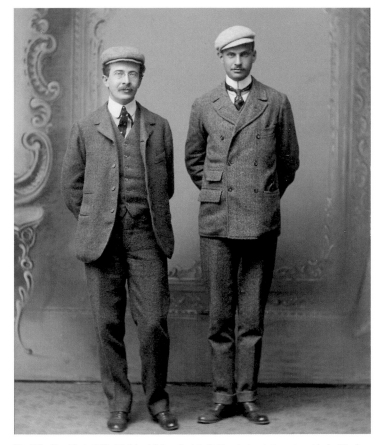

Fig. 7 Sterling Clark *(left)* with friend Robert Peck in Beijing during their service with the Ninth Infantry, 1903

After nearly two years in Washington, First Lieutenant Clark's rotation at the War Department was complete, and in May 1903 he was ordered back to his company in Beijing.[21] The situation in China had normalized and Captain Brewster was serving as commander of the American legations in Seoul and Beijing by the time Clark arrived. While on duty in Beijing for the balance of 1903 and all of 1904, Clark passed his time uneventfully and he was able to host his younger brother Stephen in the summer of 1904.[22] The only known photograph from this second tour of duty in China is a double portrait of Clark and his friend and colleague Second Lieutenant Robert Peck with both men in casual dress (fig. 7).

As Company B of the Ninth Infantry departed China and returned to duty in the Philippines in March of 1905—nearly five years after their mobilization and nearly two years into Clark's second tour of duty leading the American Legation Guard in Beijing—Clark decided to resign his commission and leave the army, reportedly due to poor health.[23] Reflecting on his character, social prominence in Washington, and career accomplishments, one notice of his resignation reported:

> He has been among the most modest, unassuming young men in the service, genial and hearty, with a courage of his convictions which attracted to him many friends, whom he kept in account of those qualities, after it was learned by accident that he was among the wealthiest young men in the country. His career has been of great credit to himself, especially during his stay in Peking [Beijing].[24]

Clark returned to New York after meeting his brother Stephen in Europe along the way that summer.[25]

Preparing for the Expedition
In the search for indications of Sterling Clark's intent to mount a scientific expedition to China there are notable activities that show he was contemplating the idea in 1905 or earlier. This evidence includes financial and other records from the period 1904–7. He deposited $20,000 in his account at the Hong Kong and Shanghai Bank in the early months of 1904—perhaps to embellish his life-

16

style during his second tour and pay for travel for himself and his brother Stephen. During his last months in Beijing in the army, he joined the Royal Geographical Society as a lifetime fellow for the not-insubstantial sum of £350.[26] He added an additional $10,000 to the bank account in China in the autumn of 1905 after he had left the army. In the spring of 1906, he deposited another £12,000 (just over $59,000) and settled a bill for $231.62 with the legendary outfitters Abercrombie and Fitch. A few months later he added an additional £8,000 (about $39,400).[27] Taken as a group, these transfers seem to indicate that Clark was amassing a reserve sizeable enough to support both the initial outlays for scientific instruments and the large expenses of engaging, supporting, and transporting a large team overland.

He kept current his club memberships in Washington during this same period—including the Army & Navy Club and the Chevy Chase Club—and may have visited Washington after leaving the army. An administrator at the Smithsonian Institution recalled in 1909 that "Mr. Clark visited the Smithsonian in 1903 or 1905 and asked for Mr. Rockhill's book on Thibet [sic]."[28] In other words, either during his time at the War Department or perhaps upon his return from China in 1905, Clark began seeking precedents—other American explorers probing into the heart of Asia and the books they produced to memorialize their observations.

Also during this time, Sterling Clark became aware of the great activity in Washington surrounding the future of the Smithsonian Institution. Founded in 1846 by act of Congress using funds from the bequest of the English scientist James Smithson, the institution occupied the modest quarters of the National Museum building for the second half of the nineteenth century. That began to change at the end of the century with the establishment of the National Zoo and other new efforts by Secretary Samuel Pierpont Langley, who led the Smithsonian from 1887 until his death in 1906. With the support of President Roosevelt, Congress appropriated funds in 1903 for a separate building, also on the National Mall, for the purpose of mounting displays of natural history. This new edifice devoted to biological and mineral specimens, built between 1905 and 1909 and opened to the public in 1911, was a visible symbol of the nation's new focus on the study of the natural world (fig. 8).

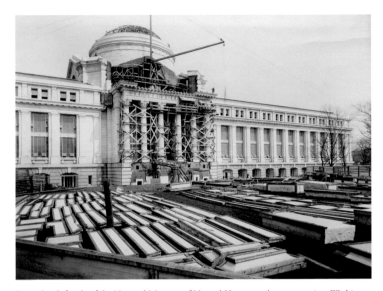

Fig. 8 South façade of the National Museum of Natural History under construction, Washington, D.C., 27 March 1909

The construction of the Natural History Museum (now known as the National Museum of Natural History) coincided with a wave of collecting expeditions by government teams, gifts from foreign countries, and private collecting by civic-minded individuals. In the most dramatic example of this period of contributions to the museum, Theodore Roosevelt and Andrew Carnegie donated the results of Roosevelt's famed post-presidential collecting trip to East Africa to hunt for white rhinoceros and other big game in 1909 to the Smithsonian.[29] While it is unknown what arrangements Sterling Clark may have made with the Smithsonian prior to departing for China, collecting animal specimens would become a major component of his expedition. The birds and mammals collected by the Clark expedition would be among the earliest and most significant specimens from China to enter the burgeoning taxonomic collections in Washington, D.C.

Thanks to the detailed description of the expedition equipment in his book *Through Shên-kan* and the survival of many of the artifacts and original expedition records in the Clark archives, a picture of Clark's original aim becomes clear (fig. 9). Equipment lists open several of the chapters and appendices of the book, including Chapter XIV: "Survey Work of the Expedition," authored by Clark himself. He procured instruments related to the collecting

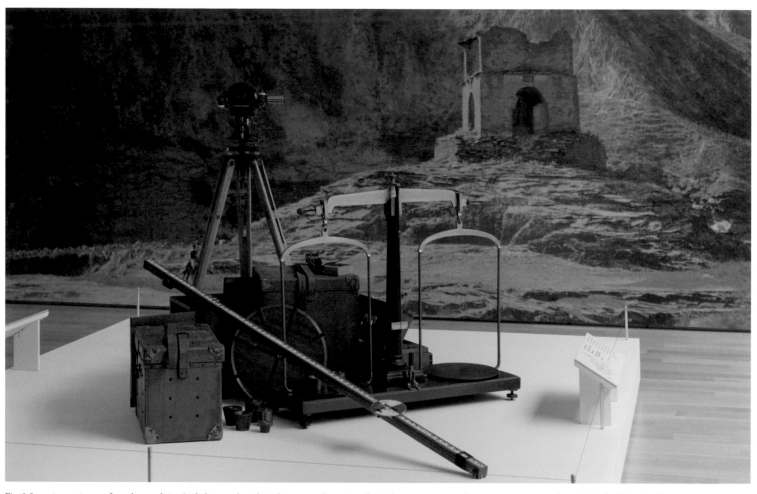

Fig. 9 Surveying equipment from the expedition (including a scale and weights, surveyor's transit and tripod, precision stopwatches, measuring tape, trunks, and a level rod) displayed at Stone Hill Center, Sterling and Francine Clark Art Institute, Williamstown, Mass., summer 2012

of meteorological data, terrestrial and astronomical surveying, and also practical supplies and provisions from purveyors in London. The opening pages of *Through Shên-kan* describe Clark having completed most of the work just before departing for Asia in late 1907.[30]

Sterling Clark assembled the expedition team mainly in the field (fig. 10). There are few documents placing Clark on his route into China: when applying for an emergency passport at the American legation in Beijing on 17 February 1908, he claimed to have left the United States on 23 August 1907 and to have plans to spend the next two years "traveling in Western China and Mongolia."[31] Clark made a stop in London where he had already purchased some surveying equipment and where he could best use his Royal Geographical Society network. Clark engaged several Britons for the expedition. Captain Henry Edward Manning Douglas of the Royal Army Medical College at Millbank—an RGS fellow and much-decorated veteran who served most recently at Rawalpindi, in the Punjab region (near present-day Islamabad, Pakistan)—took leave from his post in London to serve as the team's physician and as one of the collectors of meteorological data and biological specimens, primarily insects.[32] Clark also sought a master surveyor from that same area where Douglas had been stationed and found

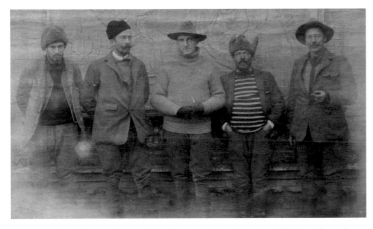

Fig. 10 Members of the expedition at Yulin, Shaanxi province, December 1908 (*from left to right:* Sowerby, Clark, Cobb, Grant, Douglas)

Fig. 11 Hazrat Ali (plate 1 from *Through Shên-kan*)

Hazrat Ali, a fifteen-year veteran of the Royal Survey of India. The choice of Ali is given great prominence in *Through Shên-kan*, and the surveying work is highlighted as a major and driving element of the expedition's purpose (fig. 11). George A. Grant, another RGS fellow then living in Beijing, joined the team as its principal interpreter and general manager.[33]

The only American Clark engaged for the expedition was the artist Nathaniel Haviland Cobb, and he too was living abroad at the time Clark hired him. A native of Danville, Vermont, Cobb had been a classmate of Clark's younger brother Stephen at Yale in 1899.[34] During his second year at Yale, Cobb left school and moved to Europe to study painting, spending long sojourns in Paris, various cities in Italy, and Tunis.[35] Stephen Clark may have introduced Sterling to Cobb in Paris during his return trip from China in the summer of 1905. At the time of Sterling's travels through Europe on the way to China in 1907 Cobb was living in Paris. Thanks to his postcards and letters to his sister Carrie, we know that Cobb traveled to China via Vienna (where he posted a note to his sister on 11 February 1908) and reached northern China in late spring (where he sent another note to his sister on 27 March), writing from Beijing: "Am going up the river by boat. Leave tomorrow evening. Love to all. Nat."[36] We can imagine that Clark and Cobb traveled together and organized the rendezvous for the expedition team at the northern city of Taiyuan, in Shanxi province.

The Expedition Commences

Clark and Ali set about their earliest recorded field work in Taiyuan on 16 May 1908. As they began their survey, Clark sought out a naturalist to coordinate the collecting of biological specimens. He found a young and ambitious Englishman working in Shanxi province named Arthur de Carle Sowerby. Born to missionary parents in the city of Taiyuan in 1885, Sowerby left China to attend boarding school in England during the Boxer Rebellion. After a year of university, he left school against his parent's wishes and lived in western Canada for a year before returning to China. In the years just after Clark's military experience in China, Sowerby found a position as a lecturer in natural biology at the European-sponsored college in Tianjin, where he started a specimen collection for display and use by students there.[37] When Clark arrived in Taiyuan in the late spring of 1908, Sowerby was on a collecting expedition through Shanxi province financed by Herbrand Russell, the 11th Duke of Bedford, a renowned colonel of the Grenadier Guards and recent president of the Royal Zoological Society. On this expedition with Russell, Sowerby served as an assistant to Malcolm Anderson (a noted naturalist) collecting mammal specimens for the British Museum.[38] Clark heard of Sowerby from a man named Dr. Edwards and wrote Sowerby in Tianjin on 4 July 1908:

I should very much like to have you go with me on a trip which I am making to the west of China as I understand you know a great deal about natural history & I do not know the slightest thing, & I understand that there is a very good field for both natural history and botany in south Kansu [Gansu], & northern Sichuan. . . . I shall be starting about August 1st toward Yulin fu at the river's summit. It will in all probability be at least a year about as I shall be traveling very slowly [*sic*] & shall take all the time necessary to see the country I pass through thoroughly.[39]

Clark asked Sowerby to name his terms and reply promptly. The reply was drafted a week later, on 12 July, in which Sowerby coyly claims to be much in demand:

I have been negotiating with a firm for a post which would mean definite employment for some ~~time~~ years. It is probable that I shall close with them, but of course when dealing with the Chinese, one never knows quite where one is, and things may miscarry. In that case I would certainly consider your kind offer. However I would like to ~~know~~ have more particulars of the work you would expect. . . . I would much prefer you to make your terms own terms [sic]. At present I have an offer from the British Museum to visit southern Shensi & they offer me £400 a year.[40]

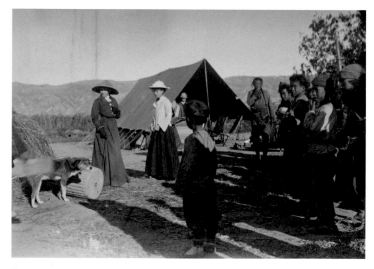

Fig. 12 Visitors—Mrs. McCoy (possibly a missionary) and Sowerby's sister—bid the expedition team farewell near Taiyuan, the day the expedition departed for Yulin, 29 September 1908

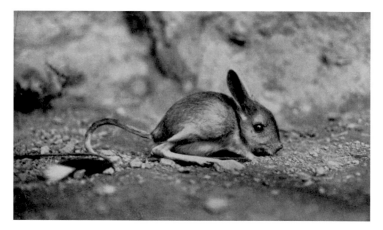

Fig. 13 Allactaga, *Allactaga mongolica longior* (plate 52 from *Through Shên-kan*)

In the end, Sowerby joined the team and began some of the expedition's most impactful work.

The expedition spent the entirety of summer 1908 in Shanxi province, establishing the baseline survey and conducting a series of out-and-back excursions into the mountains to the west of Taiyuan. These activities allowed the team to establish their working method and test all their equipment and provisions. By mid-September— fully staffed and increasingly fluent in their work—the team's attentions turned to the planning of the first overland leg of their journey, traversing the major mountain range separating the plain around Taiyuan from the Yellow River basin and the frontier of northwestern Shaanxi province at the edge of the Ordos Desert.

The expedition broke camp and began their trek through the wilderness on 29 September 1908 (fig. 12), accompanied by two policemen assigned as their escort by the Board of Foreign Affairs, "to protect the foreigners."[41] They appear to have wasted no time in beginning their animal collecting: Sowerby's field notes reflect his first specimen, a common Korean wood mouse (*Apodemus peninsulae*), was harvested on 30 September 1908 in the mountains outside Taiyuan. Over the next six months he collected over one hundred mammals, ranging in size from other small rodents to a large mountain sheep (figs. 13 and 14). Through October, they covered the several hundred miles separating Taiyuan from Yulin, a major outpost situated on the Great Wall in northwestern Shaanxi and adjacent the Ordos Desert (fig. 15).

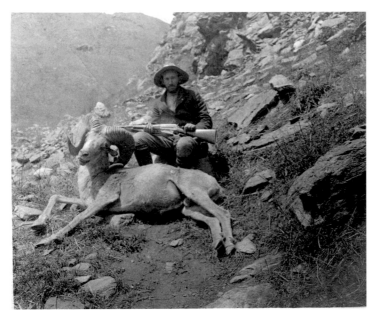

Fig. 14 Arthur de Carle Sowerby with a mountain sheep, c. 1909

Fig. 15 Horse fair outside south gate, Yulin, Shaanxi province, November 1908 (plate 16 from *Through Shên-kan*)

By midwinter, Sowerby had written the Smithsonian to announce that a large number of specimens were being shipped to them from Shanghai and that he would send along his cataloguing and paintings of the specimens. Describing his role, he wrote:

> I am engaged by Mr. Clark as naturalist to the expedition. For the last few years I have been engaged in this work; but it was not until I met Mr. Malcolm Anderson 18 months ago that I really became acquainted with the methods preferred by museums. . . . I would be glad if you would criticism [sic] my work. I do not know if the way I have catalogued? [sic] the specimens meets with your approval, neither am I sure that my report is what it should be. I would be glad for instruction on these points.[42]

He then goes on to solicit on behalf of his professional future:

> I am desirous of becoming a scientific artist and be glad of any advice on the subject. When this expedition is over I shall be looking for a permanent and settled position and am hoping that you may be able to help me.[43]

In fact, the Smithsonian administration was, at first, surprised and unaware of the expedition's intention to donate the specimens. A new secretary, the noted paleontologist Charles Doolittle Walcott, had been appointed on 31 January 1907 to replace the recently deceased Secretary Langley, with whom Clark would have met on his earlier visits to the Smithsonian in Washington.[44] Sowerby's letter alluded to the fact that Clark had asked his mother to be in touch with the Smithsonian, but she had fallen ill and apparently did not write to Washington before her death on 4 March 1909. Clark and Sowerby left the main party of the expedition and traveled to Xi'an just a few days prior to Sowerby writing. Clark then went on alone to Shanghai to procure more cash and provisions.

Meanwhile, Sowerby collected an additional one hundred fifty mammals, over eighty birds, and numerous other zoological specimens, most of which were sent to Washington in batches over the summer and into the autumn (fig. 16). Simultaneously, Ali and the bulk of the expedition continued their trek west toward Guyuan on the ancient post road connecting Shaanxi province to the Silk Road, reaching that city on 10 March. The Smithsonian administration, pleased to have the specimens but overwhelmed by the task of moving into the new Natural History Museum on the National Mall, scrambled to respond.[45] On 30 April 1909, the

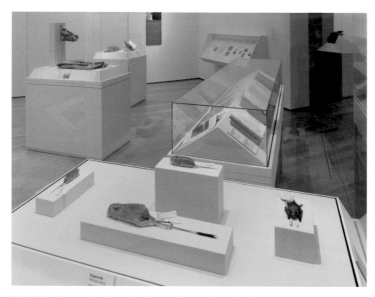

Fig. 16 Small mammals collected and prepared by Sowerby in the field and shipped to the Smithsonian in early 1909, displayed at Stone Hill Center, Sterling and Francine Clark Art Institute, Williamstown, Mass., summer 2012

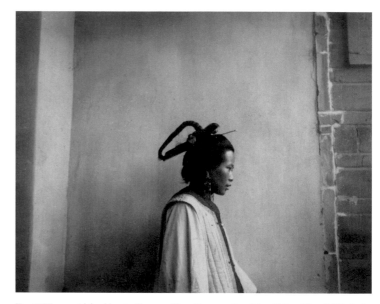

Fig. 17 Woman with headdress in Zhenyuan Xian, Gansu province (plate 44 from *Through Shên-kan*)

Smithsonian replied to Sowerby and notified him that animal traps would be sent to Shanghai to support the research while respectfully discouraging his interest in employment.[46] Two months later, in a lengthy letter, Mammals Division curator Gerrit S. Miller advised Secretary Charles Walcott to accept the gifts and briefed him on both the quality of the collection and the profile of Clark and Sowerby. He explained that the Smithsonian had received Sowerby's letter "some time about the first of March" and went on to explain:

> The collection (an unusually valuable one), consisting of well-prepared specimens of Mammals, Birds, Reptiles and Fishes, arrived in due course; but no further letter of explanation has been received.
>
> Correspondence with the executors of the Clark estate in New York has brought out the fact that the head of the expedition is Mr. Robert C. Clark [sic], whose share in the estate is estimated at $10,000,000. and that his mother died at about the time Sowerby's letter was received.
>
> Recent newspaper reports show that the expedition has been in trouble with the natives and that it is probably being abandoned.[47]

Miller suggested the text for an acknowledgment letter that praised and congratulated the expedition's work and invited the donation of the collection and any other specimens that might be collected in the future. Walcott sent the letter that same day to Clark, care of Schiller and Company, Shanghai, a shipping agent. Upon receiving the letter on 24 September, Clark replied at length and assigned great credit to Sowerby's work. Clark's reply also notified Walcott that though his own expedition had been suspended, Sowerby would continue collecting specimens in China on Clark's behalf for the benefit of the Smithsonian for a period of three years.

Concluding the Expedition

As Clark gathered more supplies, his colleagues pressed even further west into Gansu province along the post road to Lanzhou, the provincial capital at the headwaters of the Yellow River. Through arid and rugged terrain, the team took a great number of photographs of the people, places, and cultural sites they passed (figs. 17 and 18). Ali continued his surveying work, meticulously charting the six-mile swath flanking the team's path and recording all the place names for inclusion on the topographic map. Since departing Guyuan, they covered just over two hundred miles, reaching

Lanzhou on May 4 where they set up camp. During this part of the expedition, the team traveled along an established route—the eastern end of the Silk Road—where they encountered several cities and interacted with local populations. In Lanzhou, Captain Douglas performed surgery on a girl suffering from conjunctivitis (fig. 19).

But it would be in Gansu, in the wilderness outside the provincial capital, that the expedition met an unfortunate fate. The unscheduled abandonment of the expedition was forced upon the team by extreme circumstances in the summer of 1909. There was an atmosphere of suspicion and xenophobia as the Chinese Empire was in crisis. Empress Dowager Cixi had died the prior November, leaving the child Puyi (then two and a half years old) on the throne. Police detachments had been assigned to follow the Clark expedition and observe its activities, to both monitor and ensure the safety of the foreigners (fig. 20). As Clark was catching up the main group in Lanzhou, Sowerby and surveyor Hazrat Ali

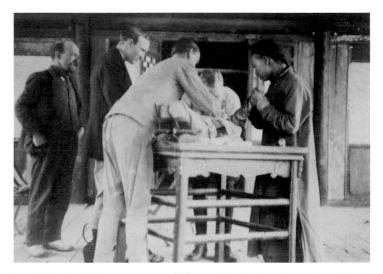

Fig. 19 Captain Douglas operating on a small Chinese girl in Lanzhou, Gansu province as Grant and Sowerby look on, spring 1909

Fig. 18 Huaguo Mountain, Bin county, Shaanxi province (plate 28 from *Through Shên-kan*)

began to venture southward into the high and rugged mountains at the headwaters of the Yellow River (fig. 21), with a plan to reach the town of Minzhu (near modern-day Linxia). After camping in the hamlet of Majia Diancun near a pass fifteen miles west of Lanzhou on the night 20 June, Ali left camp alone. Sowerby conveys the situation in *Through Shên-kan* with excerpts from his diary entries:

Although everyone appeared perfectly friendly, I thought it better to re-iterate my warnings to Hazrat Ali never to work unarmed and always to take one of the Chinese soldiers with him on his excursions, as a sign that the party was traveling under official sanction. . . . Rain fell heavily during the day and . . . I did not expect Hazrat Ali to return until towards nightfall. . . . As night drew in without his returning, I decided to take out guides to his assistance, in case he should lose his way in the darkness. As our party was on the point of setting out, one of the plane table coolies crawled into camp, covered with wounds and with his arm broken. The poor fellow informed us that the survey party had been attacked, without warning or provocation, by a large gang of natives from the villages on a plateau about six miles east of our camp. The man himself had been severely assaulted and robbed of his watch, but had made good his escape. He knew nothing of the fate of the surveyor or of the other plane-table coolie. His assailants had informed him that they intended to make an immediate attack on our camp . . . in order to kill all the foreigners. On hearing this, the servants became panic-stricken, and vainly implored me to return forthwith to Lan-chou [Lanzhou]. The night was now pitch dark and the guides flatly refused to assist me in searching for traces of the surveyor.[48]

23

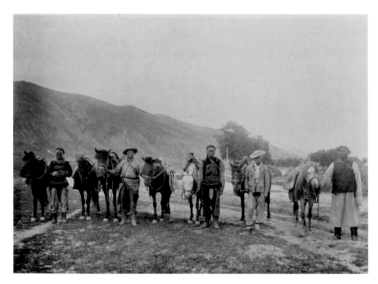

Fig. 20 The military escort that accompanied the expedition back from Lanzhou, late summer 1909 (plate 41 from *Through Shên-kan*)

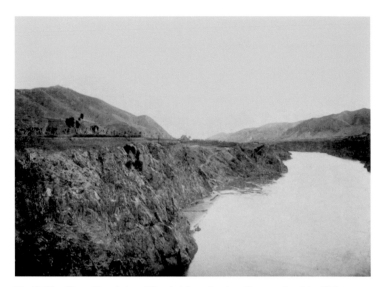

Fig. 21 Yellow River at Shao-shui-tzu [Xiangshuizi] near Lanzhou, Gansu province (plate 33 from *Through Shên-kan*)

Sowerby sent a message back to the base camp in Lanzhou informing Clark and asking him to come immediately to their current location. At first light the other servant appeared, also bloodied and also without word of Ali's fate. Sowerby's search party found the place of Ali's abduction and observed tracks from his hobnailed boots leading to the end of a ravine. His body was not recovered.

Sowerby and Clark rendezvoused on the mountain road and investigated the matter without assistance from the Chinese guards. An armed altercation between villagers and the expedition team followed in which two on each side were injured and one villager killed. In a letter sent to the Smithsonian on 12 July from Lanzhou, Sowerby summarized what had happened:

> I regret to have to inform you that owing to the murder here of one of our party & the attitude of the Officials, the Expedition has been brought to an end. . . .
> We reached Lanchow [Lanzhou] on May 24th when I set about preparing for the difficult journey southward to Minchow [Minzhou]. I tried a little collecting here but found that the three years [of] famine that has visited this place has killed off pretty well everything.

I left Lanchow for Minchow on the 12th of June, but my military escort (an essentiality while traveling in these out of the way places) deserted me, & after knocking about in the mountains south of here for week I was recalled by Mr. Clark who feared for my safety.

On June 20th I started out once more for Minchow—this time accompanied by Hazrat Ali the surveyor & plane-tabler of the party. On the 21st he was attacked & killed while out doing work on a peak, by a crowd of desparate [*sic*] mountaineers—(a remnant of the Boxers).[49]

He would recall the situation more dramatically and also with more sympathy for the Chinese villagers in his memoir, written in the 1950s, stating that perhaps the attackers were desperately impoverished and that they may have encountered Ali during a religious procession and overreacted upon confronting a Muslim.[50]

In fact, Clark's expedition had been recalled by the American and British embassies. Clark departed Lanzhou on 2 July 1909, with Captain Douglas, bound for Beijing; Grant and Sowerby followed by a separate route on 15 July and continued collecting specimens into early August along the way (fig. 22). A court of enquiry was convened by the British, American, and Chinese governments,

24

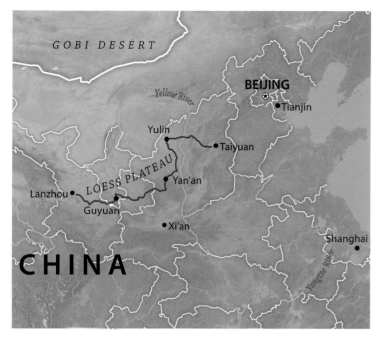

Fig. 22 Map of the expedition's westerly route from Taiyuan along the Loess Plateau, culminating in Lanzhou

Presided over by Walter Hililer, a retired British diplomat and advisor to the Chinese government at the time.[51] No punitive action was taken, nor were reparations offered, much to Clark's dissatisfaction. Sowerby sent the final set of specimens to the Smithsonian from Taiyuan in November.[52] By then Sowerby had married, and he and Clark had agreed to the terms of Clark's continued support of Sowerby's collecting activities. Clark stipulated that Sowerby and his new wife travel to England the following summer for instruction in surveying and astronomical observation.[53] They did so in the summer of 1910, departing in May on the Trans-Siberian Railway. Once in London, Sowerby met with many naturalist contacts. These included the purveyors Clark had used; Oldman Thomas, who had published the findings of the Bedford expedition; and Gerrit S. Miller from the Smithsonian.[54]

Legacy: Plans and Publications

Sterling Clark's departure date from China is unknown, but he was in Paris by the early days of 1910 and met his future wife, Francine Clary, in late March. That autumn he bought a grand townhouse at 4 rue Cimarosa.[55] In between, Clark visited the United States, renewed his passport on 1 July in New York City, and wrote a brief note to Sowerby on stationery from his Iroquois Farm in Cooperstown on 24 July. Writing in August 1910 from aboard the Lusitania, Clark confirmed his commitment to support Sowerby's work through October 1912 and requested that he draft "a short account of all that was done in your department . . . the animals."[56] He wrote Sowerby again (this time probably from Paris) on 9 September with detailed instructions on coordinating the publication of *Through Shên-kan,* connecting with people able to teach Sowerby more about surveying and astronomical observation, requesting he travel to New York and Washington in November, and suggesting a new campaign of collecting back in China.[57] Sowerby later recalled meeting with Clark in Paris during their European sojourn as well to review the same matters. The record of the expedition and Sowerby's future collecting activities appear to be at the forefront of everyone's concern.[58] Meanwhile, scientists at the Smithsonian published the first findings about the specimens collected. Among the mammals, birds, and insects were several new discoveries and several type specimens.[59]

Through Shên-kan was published in August 1912 by T. Fisher Unwin in London. Positive reviews of the book appeared in the March 1913 issue of the Royal Geographical Society's monthly *Geographical Journal*. That review praises the book as containing "within its cover more information on widely different subjects than is generally to be met with in books of travel."[60] Singled out for particular commendation are the map (see fig. 28) and the "number of excellent photographs and coloured plates, and some extremely interesting studies of the zoology and geology of North China." Among others who took note of the Clark expedition was the Danish explorer Frits Holm, who threatened to file a slander suit against Clark for an offhand mention made in chapter six about a story Clark and Sowerby heard in Xi'an about "a Swedish collector" who tried to "carry off" the so-called Nestorian Tablet—an important stele in the city which had in 1907 been moved to the Beilin site for safekeeping.[61] In 1915, the eminent ethnologist William Churchill reviewed the book for the *Bulletin of the American Geographical Society* in brief but glowing terms:

Fig. 23 Visitors to an exhibition of Li Ju and Clark expedition photographs at the Ningxia Library, December 2009

The record of the territory traversed . . . is most complete, the narrative is clear and ever interesting, the route map is drawn with scrupulous care, the astronomical determinations of position are all that could be desired, and the zoological collections have all been monographed by competent specialists. Few expeditions of recent adventure have accomplished so much in so short a time, still fewer have presented the results in such satisfactory form.[62]

Clark continued to support Sowerby with an annual stipend of £200 plus expenses for his continued collecting in China, always on the condition that specimens be forwarded to the Smithsonian. The outbreak of World War I in Europe and Asia caused both Clark and Sowerby to enter into military service: Clark as a Major in the Inspector General's Office in France, and Sowerby on special duty in the British military as a liaison to the Chinese Labour Corps in Normandy. Nevertheless, the two were able to meet at Clark's home in Paris at least twice during the war. Sowerby returned to China after the armistice.[63] For the rest of his active scientific career, Sowerby enjoyed Clark's patronage and sent nearly thirteen hundred mammals and one thousand birds to the National Museum of Natural History up through the 1940s. Even today, the Sowerby collection forms the nucleus of the Chinese holdings in those departments. As the Communists took power, Sowerby left China and settled in Washington. He donated his research papers to the Smithsonian upon his death in 1953.[64] Among those records are thousands of photographs, his correspondence with Clark, and bank records demonstrating Clark's steadfast commitment to supporting Sowerby's career as a naturalist.

A Centennial Commemoration

As the anniversary of the Clark expedition approached, the Clark began examining its archives and those of the Smithsonian to investigate how to best honor the accomplishments and introduce to the public the materials and intellectual legacy of this venture. While the scientific community has absorbed the importance of the Sowerby collections of specimens at the Smithsonian, Sterling Clark had been overlooked as the patron of the project, and the connection of the scientific specimens to *Through Shên-kan* had been lost in the secondary literature. During the investigation, a cache of dozens of Clark expedition-related photographs were found among the Sowerby Papers at the Smithsonian, expanding the photographic record beyond the more than sixty plates so praised by reviewers of the book. The Clark decided to mark the expedition centennial by mounting a series of photography exhibitions in the Chinese communities traversed by the expedition. Three shows—in Taiyuan, Xi'an, and Lanzhou—opened in the fall of 2008. Original copies of *Through Shên-kan* were given to the libraries in those cities and a facsimile of the book was produced by the Clark and distributed widely as well. Simultaneously, a digital version of the book and the expedition photographs were made available on the Clark web site. A group of students from the Oxford University Exploration Club retraced the expedition route by modern means in the summer of 2008.[65] Their expedition—facilitated by public transportation, in place of Clark's mule train—was registered with the Royal Geographical Society, London, and introduced Clark and Sowerby's studies to a new generation of scholars and explorers.

26

Those early and earnest initiatives inspired, in turn, rather exceptional activities by our colleagues in China. Photographer Li Ju and his compatriots in the Great Wall Society have retraced the expedition route several times and rephotographed more than thirty of the sites, expanding the conversation into the continuity and change in the Chinese landscape and the fate of China's architectural heritage in the increasingly modernized and urbanized world. Four more photography exhibitions have been held—in Shanghai, Beijing, Yinchuan, and Wuhan—juxtaposing the vintage views with the modern ones created by Li Ju and his associates (fig. 23). Professor Shi Hongshaui of Shaanxi Normal University in Xi'an, a historian of Western explorers active in Qing dynasty China, prepared a critical translation in Mandarin of *Through Shên-kan*, which was published in Shanghai in 2010. Both efforts were featured in Chinese media, including a four-part television series in late 2009 and an article on the modern photography project that appeared in *Chinese National Geography* in July 2010. The television program, *Through Shaanxi and Gansu*, highlighted the activities of Li Ju and Professor Shi and featured actors in period dress reenacting key episodes from the Clark expedition. It was broadcast multiple times on China Central Television's CCTV-4 and on CCTV International.

In summer 2012, several Clark projects take their inspiration from the expedition. At The Explorers Club in New York City— a townhouse originally built in 1911 by Sterling Clark's brother Stephen to serve as his home—contemporary artist Mark Dion has created a special installation, *Phantoms of the Clark Expedition*, which responds to both the history of exploration and to Sterling Clark's travels in China. In Williamstown, the exhibition *Through Shên-kan: Sterling Clark in China* examines the themes of the expedition and is presented in the Stone Hill Center galleries (figs. 24 and 25), where it is complemented by an installation of pairings of vintage expedition images with modern images by Li Ju of the expedition sites. These projects provide a context for one of the most ambitious summer exhibitions in the Clark's history— *Unearthed: Recent Archaeological Discoveries from Northern China*. On view in the main exhibition galleries, this show focuses on the antiquities and the practice of archaeology of China. Highlights include items from three astonishing tomb excavations from Shanxi and Gansu provinces, the beginning and end points of the Clark expedition. These areas are among the most fertile grounds of archaeological research in China, where new discoveries continue to expand and redefine our understanding of ancient Chinese culture.

While Sterling Clark perhaps made his greatest contribution to posterity as an art collector, that avocation developed later, after he had left his days as an adventurer behind. Indeed, his activities in China during the early years of the twentieth century were limited to the collection of scientific data and zoological specimens, rather than the antiquities that were sought after by so many other visitors from the West. One hundred years later, the Institute that bears his name has enjoyed the support of and exceptional loans from institutions across *Shên-kan*, benefiting from fruitful collaborations with today's stewards of China's cultural heritage.

Fig. 24 Scientific publications, correspondence, and recent Chinese publications related to the expedition, displayed at Stone Hill Center, Sterling and Francine Clark Art Institute, Williamstown, Mass., summer 2012

Notes

Primary research for this essay began in late 2010 when it became clear that consultation of resources beyond Williamstown were necessary. Over the period 2007–8, Sterling and Francine Clark Art Institute archivist Lacy Schutz began a survey of the Arthur de Carle Sowerby Papers at the Smithsonian Institution Archives in Washington, D.C. Her work included the identification and digitization of some one hundred forty vintage photographic prints and the documentation of the contents of Sowerby's extensive correspondence with Clark. Her systematic cataloguing of pertinent items (letters, equipment, and Clark's personal effects) in the Clark archives proved an invaluable resource. On my research trips to Washington, I studied the Sowerby Papers in greater detail (consulting particularly his financial records and all the letters) as well as the administrative records related to the Clark expedition (including internal memoranda and period correspondence) with the help of Smithsonian archives technician Mary Markey. At the National Museum of Natural History, I consulted specimens within the division of birds and mammals, within the Department of Vertebrate Zoology, in the company of supervisory specialists Christopher Milensky and Darrin Lunde, respectively. Details on the Clark family's patronage of the sciences at Williams College were accessed primarily through the Archives and Special Collections, with the particular help of archivist Sylvia Kennick Brown. Sterling Clark's military records and passport applications are held in the National Archives and Records Administration and were accessed in their digital format through Ancestry.com. Newspaper reports of Clark's activities during 1899–1910 were accessed principally in their digital format through the Library of Congress's *Chronicling America* portal (http://chroniclingamerica.loc.gov). For more information and a checklist of the exhibition *Through Shên-kan: Sterling Clark in China*, see the Clark's microsite: http://clarkart.edu/exhibitions/through-shen-kan/content/exhibition.cfm.

1. "Edward Clark," in *Alumni Obituaries*, 1875–1885, 304–6, Williams College Archives and Special Collections, Williamstown, MA.

2. Williams College Board of Trustees, Minutes, 1785–1894, III, 93, Williams College Archives and Special Collections, Williamstown, MA.

3. *Alumni Obituaries*, 306. See also Trustees' Minutes, 1785–1894, III, 115, 123, 148, 186, 195–96. Edward Clark's gifts are recorded in the college trustees' minutes and also transcribed into a modern ledger. They include a $10,000 gift in 1878, funding of the Wilder Cabinet acquisition, deeding of the completed Clark Hall, and his subsequent bequest of $50,000.

4. Trustees' Minutes, 1905–1913, 61 and 64. A storm in the autumn of 1906 caused one of the exterior walls of Clark Hall to give way. The college's decision to raze the building appears in the trustees' minutes of October 1906.

5. Quarterly Statement, July–September 1907, Financial Series, Sterling and Francine Clark Papers, Sterling and Francine Clark Art Institute, Williamstown, MA. The payment of $1,500 from Sterling Clark's Cooperstown bank account was recorded in this quarterly statement. Interestingly, Sterling Clark had by this time inherited from his grandfather several Hardenbergh-designed properties in New York City (such as the Ontiora and the Van Corlear on opposite corners of 55th Street and Seventh Avenue), the expenses and revenues from which are recorded in the same bank statements. On the architectural significance of these apartment blocks, see Christopher Gray, "Behind a Scruffy Facade, Kinship to the Dakota," *New York Times*, 9 March 1997 and Gray, "An Unusual Design is Improved, and a Landmark is Born," *New York Times*, 17 December 2006. See also Gray, "The Clark Family, Patrons of New York Architecture," *Journal of the Clark Art Institute 6* (2005): 16–22. The new Clark Hall was dedicated on 7 October 1907 on the occasion of the induction of President Harry August Garfield.

6. A framed copy of Sterling Clark's army commission dated 1 September 1899 is in the archives of the Sterling and Francine Clark Art Institute.

7. For a sketch of Clark's army career, see Fred R. Brown, *History of the Ninth U.S. Infantry* (Chicago: R. R. Donnelly & Sons, 1909), 695. Monthly reports of Clark's duty stations are available through the National Archives; see *Returns from Regular Army Infantry Regiments, 9th, 1899–1905*, National Archives and Records Administration, Washington, D.C.

8. Brown, *History of the Ninth*, 347.

9. Michael Conforti, "The Clark Brothers: An Introduction" in *The Clark Brothers Collect: Impressionist and Early Modern Paintings*, by Michael Conforti et al. (Williamstown, MA: Sterling and Francine Clark Art Institute, 2006), 13–17.

10. Brown, *History of the Ninth*. See pp. 423–

24 for a reference to Clark sending a telegram to the command during the mobilization near Capas; p. 438 for the U.S.S. Logan en route to China; and pp. 449–50 on preparing for battle. See also *Returns from Regular Army Infantry Regiments*, June 1900.

11. There are eight photos in all, three of which bear Clark's inscriptions. They appear to have been taken within the first year after the battle by army engineers.

12. Clark is listed among those "mentioned for gallantry, etc., recommendations for brevets, or medals of honor, or certificates of merit being made." Brown, *History of the Ninth*, 469.

13. *Returns from Regular Army Infantry Regiments*, July 1901.

14. Eaton Albert Edwards et al., *Notes of Military Interest for 1901* (Washington, D.C.: Adjutant General's Office, 1902), and Robert S. Clark et al., *Notes of Military Interest for 1902* (Washington, D.C.: Adjutant General's Office, 1903).

15. *New-York Tribune*, 10 December 1901.

16. *The World*, 18 July 1902.

17. *New York Evening World*, 4 October 1902.

18. *New-York Tribune*, 23 December 1902.

19. *New York Daily Tribune*, 2 August 1905. This paper included notice of Clark's resignation from the army, a rumor of the cost of the cotillion, and an anecdote of his high living.

20. *New-York Tribune*, 15 January 1903 and 22 February 1903. Social notices appearing in the New York and Washington newspapers of the day frequently mention Clark.

21. Special Order n. 14, Adjutant General's Office, Washington, D.C. Clark reported for duty on 28 August 1903.

22. Daniel Cohen-McFall, Mari Yoko Hara, and Sarah Lees, "Chronology," in Conforti et al.,

Clark Brothers Collect, 300.

23. "Lieut. Clark Leaving the Army. His Health Would Not Allow of His Going to the Philippines," *New York Daily Tribune*, 2 August 1905.

24. Ibid.

25. On Clark's resignation, see Brown, *History of the Ninth*, 695 and newspaper coverage such as *The Washington Post*, 30 July 1905 and *New York Daily Tribune*, 2 August 1905 (cited above). On the return trip via Europe, see *Freemans' Journal*, 3 August 1905 as cited in Cohen-McFall, Hara, and Lees, "Chronology," in Conforti et al., *Clark Brothers Collect*, 301.

26. Certificate of candidate for election: Robert Sterling Clark, dated 28 January 1905 and stamped "Proposed 27 March 1905" and "Elected 10 April 1905," Royal Geographical Society Archives, London. Clark petitioned for membership from Beijing, sponsored by two RGS fellows then living in Beijing: Ben H. Mundy and George Ernest Morrison. The latter's address is listed care of the British Legation in 1905. On the payment itself, see Financial Series, Sterling and Francine Clark Papers, Sterling and Francine Clark Art Institute, Williamstown, MA, shown as $170.45 on the April–July 1905 statement of his Cooperstown bank account.

27. Financial Series, Sterling and Francine Clark Papers, Sterling and Francine Clark Art Institute, Williamstown, MA.

28. Memorandum, W. de C. Ravenel to Mr. Rathbun, 1 April 1909, Smithsonian Institution Archives, Record Unit 192, United States National Museum, Permanent Administrative Files (hereafter cited as United States National Museum, Permanent Administrative Files). The book in question is likely William Woodville Rockhill, *Diary of a Journey through Mongolia*

and Thibet in 1891 and 1892 (Washington, D.C.: Smithsonian Institution, 1894), in which Rockhill recounted his covert visit to the holy city of Llasa. It seems likely that during his time at the War Department and into his second tour of duty in Beijing, Clark came in contact with Rockhill, an honorary corresponding member of the Royal Geographical Society and a notable American explorer of China. Rockhill was serving the Bureau of American Republics in Washington in 1903 and was appointed Minister of the American Legation in Beijing in 1904, serving there through 1909 before his appointment as ambassador to St. Petersburg, Russia, in 1910. Annotated alphabetical list of fellows by year, 1903–1911, Royal Geographical Society Archives, London.

29. Smithsonian Institution, *The Smithsonian Institution* (Washington, D.C.: Smithsonian Institution, 1957), 15.

30. Robert Sterling Clark and Arthur de C. Sowerby, *Through Shên-kan: The Account of the Clark Expedition in North China, 1908–9* (London: T. Fisher Unwin, 1912), 2.

31. Passport applications, National Archives and Records Administration, Washington, D.C.

32. Annotated alphabetical list of fellows 1907, 113, and 1908, 116, Royal Geographical Society Archives, London. Douglas had been an RGS member since 1903, when his location is listed as "Raval Pindi." In 1908 his address is listed as "College, Millbank."

33. Annotated alphabetical list of fellows 1905, 124, Royal Geographical Society Archives, London. Grant had been a member since 1904; his address is listed as Peking [Beijing] from then until 1909.

34. Dudley Payne Lewis, ed. *History of the Class*

of 1903, *Yale College* (New Haven, CT: Yale University, 1913), 85.

35. E. Bénézit, et al., eds. *Dictionary of Artists* (Paris: Gründ, 2006), 3: 1151. Cobb would later settle in Rome in 1914.

36. Mansfield M. Batchelder, "Uncle Nat's Story. Nathaniel H. Cobb, the Artist" (unpublished manuscript, 2011), 49. Archives of American Art, Washington, D.C. Sowerby's autobiography mistakenly states that Cobb was "a personal friend of the leader." Arthur de Carle Sowerby, in collaboration with Alice Muriel Sowerby and Joan Evelyn Stone, *The Sowerby Saga* (Washington, D.C., 1952), 112.

37. Sowerby et al., *The Sowerby Saga*, 104–6.

38. On the Bedford Expedition, see Sowerby in *Through Shên-kan*, 79–80; *The Sowerby Saga*, 106–10; and Richard Raine Sowerby, *Sowerby of China: Arthur de Carle Sowerby, F.R.G.S., F.Z.S.* (Kendal: Titus Wilson and Son, 1956), 3–5.

39. Clark to Sowerby, 4 July 1908, Smithsonian Institution Archives, Record Unit 7263, Sowerby, Arthur de Carle, 1885–1954, Arthur de Carle Sowerby Papers (hereafter cited as Sowerby Papers).

40. Sowerby to Clark, 12 July 1908, Sowerby Papers.

41. *Through Shên-kan*, 6.

42. Sowerby to Smithsonian, 9 Feb 1909, United States National Museum, Permanent Administrative Files.

43. Ibid.

44. Ellis L. Yochelson, "Charles Doolittle Walcott, 1850–1927: A Biographical Memoir" in *National Academy of Sciences, Washington, D.C., Biographical Memoirs* 39 (1967), 488.

45. Memorandum, Ravenel to Rathbun, 1 April 1909, United States National Museum, Permanent Administrative Files. This memo demonstrates how the Smithsonian tried to ascertain who Sowerby and Clark were and what their plans were, stating that Clark had perhaps visited "in 1903 or 1905," that he was "a man of independent means," and "Mr. Miller thinks that he may possibly have arranged this matter in a personal interview with the Secretary. The material he sends through Mr. Sowerby is very fine, and Mr. Miller wishes it accepted."

46. Typed copy of Ravenel to Sowerby, 30 April, 1909, United States National Museum, Permanent Administrative Files.

47. Miller to Walcott, 9 July 1909, United States National Museum, Permanent Administrative Files.

48. Clark, *Through Shên-kan*, 64–65.

49. Sowerby to Ravenel, 12 July 1909, United States National Museum, Permanent Administrative Files.

50. Sowerby et al., *The Sowerby Saga*, 129–35.

51. Ibid., 136–37.

52. Sowerby to Ravenel, 16 November 1909, United States National Museum, Permanent Administrative Files. Sowerby writes: "In a day or so I shall be shipping another consignment of specimens (no. 4) which I hope will reach you safely. This last collection has been made in the immediate vicinity of Taiyuan fu & in the mountains to the east…"

53. Sowerby et al., *The Sowerby Saga*, 142.

54. Ibid., 146

55. Conforti et al., *Clark Brothers Collect*, 36–39.

56. Clark to Sowerby, undated (but opening with reference to a letter of 5 August), Sowerby Papers.

57. Clark to Sowerby, 9 Sept 1910, Sowerby Papers. In the letter, apparently sent from Paris, Clark refers to an upcoming trip to Italy and suggests that Sowerby should write him care of Morgan Harjes, a shipping agent located at 31 Boulevard Haussman.

58. Sowerby et al., *The Sowerby Saga*, 146.

59. Gerrit S. Miller, "A New Carnivore from China," *Proceedings of the United States National Museum* 38 (August 1910): 385–87, and Miller, "Four New Chinese Mammals," *Proceedings of the Biological Society of Washington* 24 (February 1911): 53–56.

60. W.R.C., "Researches in Northern China," review of *Through Shên-kan* by Robert Sterling Clark and Arthur de Carle Sowerby, *The Geographical Journal* 41, no. 3 (March 1913): 276–77.

61. For the mention of the Nestorian Tablet and its recent move, see *Through Shên-kan*, 49. Letters from Clark to Sowerby captioned "4 rue Cimarosa, Paris, Aug 12th, 1913" and "On board the Cunard R.M.S. Lusitania, Oct 16th 1913" request that Sowerby send newspaper accounts substantiating the story as Clark's lawyers in New York prepared his reply to the Von Holm threat. See also letter from the law firm to Sowerby dated 3 Nov 1913, thanking Sowerby for sending materials. Sowerby Papers.

62. William Churchill, review of *Through Shên-kan: The Account of the Clark Expedition in North China, 1908–9*, by Robert Sterling Clark and Arthur de C. Sowerby, *Bulletin of the American Geographical Society* 47, no. 1 (1915): 62.

63. R. R. Sowerby, *Sowerby of China*, 29–31.

64. Sowerby Papers. His archival donations were catalogued in the 1980s and were the basis for a senior thesis at Harvard by Jonathan Sinton in 1986, "Arthur de Carle Sowerby, a Naturalist in Republican China."

65. Ginny Howells and Victoria Thwaites, "Revisiting Shên-kan," *Journal of the Clark Art Institute* 9 (2008): 16–19.

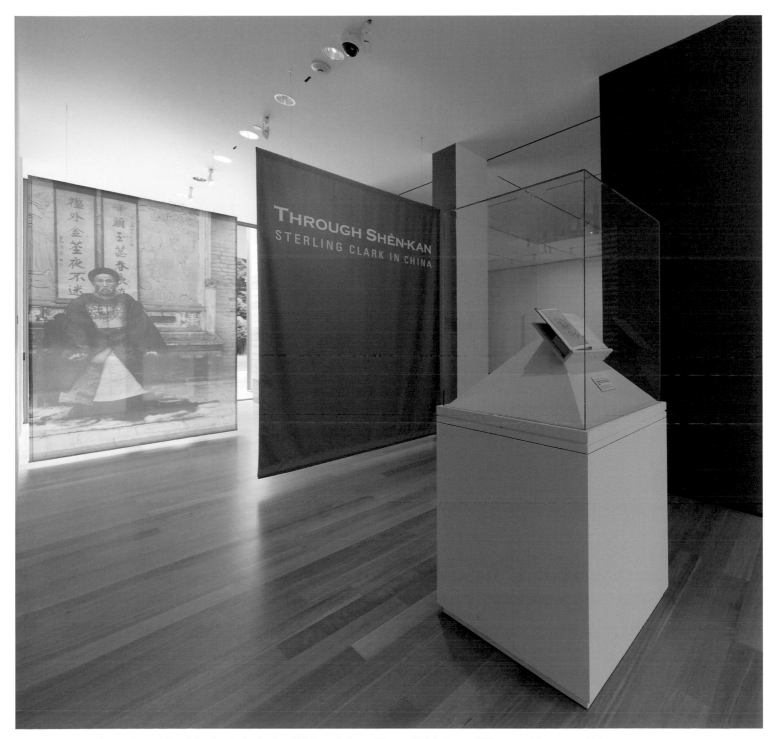

Fig. 25 Entry gallery with 1912 edition of *Through Shên-kan,* displayed at Stone Hill Center, Sterling and Francine Clark Art Institute, Williamstown, Mass., summer 2012

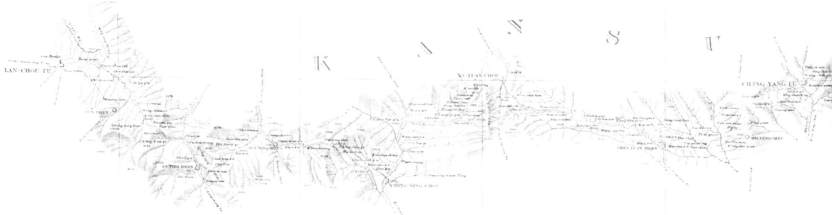

ROUTE OF THE CLARK EXPEDITION
THROUGH SHANSI, SHENSI, AND KANSU.
1908-9.

The Clark Expedition 1908–9: Context and Achievements

Shi Hongshuai

During the late Qing dynasty (1870–1911), expedition teams and explorers from Great Britain, the United States, Germany, and France conducted many investigations in the Loess Plateau region of northwestern China, collecting large amounts of data. The Clark expedition team from the United States conducted the most significant of these surveys from 1908 to 1909. They surveyed and documented the hinterland of Shanxi, Shaanxi, and Gansu provinces, focusing on geology, meteorology, zoology, and botany, as well as urban environments, commerce, population, and communications. It was the most comprehensive investigation of the natural and cultural phenomena of the Loess Plateau conducted by foreigners during this era.

Academics have done extensive research on the explorations by Westerners in the late Qing dynasty, especially on their forays into the border regions in northwestern and southwestern China. However, until now there has yet to be a significant study on the Clark expedition of the Loess Plateau.[1] This essay is based on the book by Sterling Clark and Arthur de Carle Sowerby published in 1912, *Through Shên-kan: The Account of the Clark Expedition in North China, 1908–9* (henceforth referred to as *Through Shên-kan*);[2] archival documents that shed light on the formation of the expedition team, the intended route, and the methods of investigation used; and contemporary research on other Western researchers and explorers active in the Loess Plateau during the late Qing dynasty.

Formation of the Expedition Team and Goals of the Expedition
In the post-Opium War period, the gates of China were opened and Western powers established trading ports along the country's seas and rivers. In addition, governments and organizations (such as museums and geographic societies) sent expedition teams and explorers to investigate remote regions of the country. From the late nineteenth through the early twentieth century these trips increased in frequency.

Unlike most Western expeditions sponsored by governments or institutions, the Clark expedition was funded by American Robert Sterling Clark personally. Clark came to China for the first time in 1900 as a military officer (see fig. 6), and he participated in battles in Tianjin and Beijing. Those experiences spurred his interest in

the country, and upon returning to America, he began to organize a zoological and anthropological expedition to northern China. The expedition began in 1908, after three years of planning.[3] Some scholars have assumed that the National Museum of Natural History in Washington, D.C., organized the expedition.[4] But according to Clark's own account in *Through Shên-kan* and the analysis found in *Researches in Northern China*, published in the third issue of *The Geographical Journal*,[5] Clark alone initiated, organized, and amply funded the expedition.[6]

In the first half of 1908, Clark recruited the team that would participate in the expedition in China. Clark began by purchasing equipment in Britain and other places. He hired from India Hazrat Ali, who had worked with the Survey of India for over fifteen years and spoke seven languages fluently, including English and Chinese.[7] Western expedition teams visiting China in the late Qing dynasty, especially teams from Britain, often hired surveyors from Indian survey organizations due to their rich experience and familiarity with Asian geography, and Clark followed in this tradition.

In China Clark hired George A. Grant (a Briton living in Beijing) to act as translator and team manager.[8] Clark traveled by train from Beijing to Taiyuan, the most westerly terminus of the rail system. There the team assembled: the artist Nathaniel Haviland Cobb, the meteorologist and doctor H. E. M. Douglas (based with the British Royal Army Medical College, London); and the translator and naturalist Arthur de Carle Sowerby. Sowerby, the son of a missionary for the British Baptist church, was born in Taiyuan. He had experience with local conditions in Shanxi and Shaanxi and spoke fluent Chinese. Sowerby had just completed an exploration with the Duke of Bedford's expedition team led by American zoologist Malcolm Playfair Anderson in northern China before he joined the Clark expedition.[9]

Besides the six core members (Clark, Ali, Grant, Cobb, Douglas, and Sowerby), the Clark team also hired two Chinese surveyors, nine servants, fifteen attendants to look after the mules, five attendants to care for the horses, and one hunter. By the time they set off from Taiyuan, the team had grown to thirty-eight members and fifty-eight animals: one hunting dog, five donkeys, eight horses, and forty-four mules (fig. 26).[10]

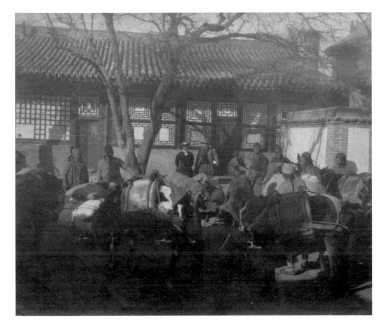

Fig. 26 Caravan preparing to depart from Taiyuan, September 1908

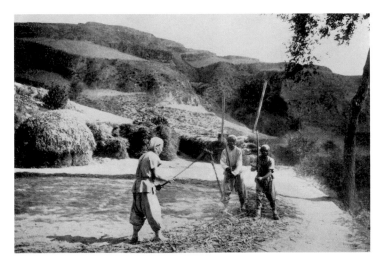

Fig. 27 Threshing floor, Shanxi province (plate 6 from *Through Shên-kan*)

As an heir to the Singer sewing machine company fortune, Clark had an abundance of financial resources. The team purchased advanced equipment, which allowed for thorough and systematic investigations over a long period of time and a vast region. Sophisticated instruments, including barometers, telescopes, and plane tables, enabled the team to document meteorological and astronomical data; measure longitude, latitude, and altitude; and map the region. The expedition team also carried items like a Kodak camera, rifles, bullets, and medical equipment.

After reviewing the diverse material recorded in *Through Shên-kan,* it is clear that the Clark expedition team focused on natural sciences. Their tasks included collecting animal samples; surveying topography (longitude, latitude, altitude), drawing maps, and surveying geology; observing, measuring, and documenting daily meteorological conditions; photographing landforms, ancient historical sites, animals, and people; and studying living conditions, agriculture, and trade (fig. 27). In terms of specimen and data collection, the Clark expedition offers more comprehensive content than any single-discipline exploration carried out by Western expedition teams in the Loess Plateau region.

Summary of Route and Regions Covered

On 16 May 1908, the Clark expedition began to make meteorological observations and measurements, which marked the beginning of their investigations of the Loess Plateau. The team disbanded in Taiyuan on 12 September 1909 after finishing their expedition.[11] It was an expedition that lasted 480 days and covered approximately 3200 kilometers through Shanxi, Shaanxi, and Gansu, as well as what is today southern Ningxia and western Henan (fig. 28). After factoring in the amount of time devoted to hiring staff and purchasing equipment, the entire expedition took longer than eighteen months.

Clark's initial expedition plan was an ambitious, full-circle route. The team departed from Taiyuan during the fall of 1908. They had planned to cross Shaanxi and Gansu, pass through the Sichuan-Tibetan border to reach Chengdu, hike along the Min River to Xuzhou (present-day Yibin), travel along the Yangtze River to Shanghai by boat, and then ultimately return to America.[12] The route would have included the hinterland of the Loess Plateau, eastern Tibetan highland, the Sichuan basin, and the middle to lower reaches of the Yangtze River. The plan shifted when Hazrat Ali was killed in the mountainous area south of Lanzhou on 21 June 1909. Only half of the initial route was covered because the team was forced to return to Taiyuan.

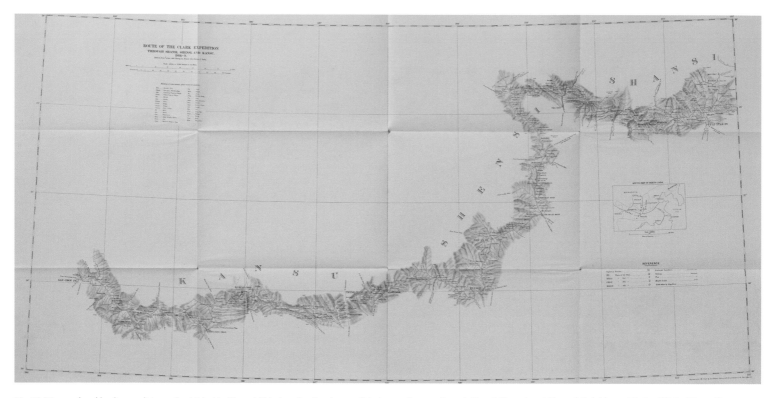

Fig. 28 Map produced by the expedition and published in *Through Shên-kan,* showing the expedition's westerly route through Shanxi, Shaanxi, and Gansu (labeled here with their Wade-Giles spellings as Shansi, Shensi, and Kansu). Altogether, the expedition passed through more than twenty prefectures, subprefectures, and counties.

Clark's expedition from Taiyuan to Lanzhou included passing through the hinterland of the Loess Plateau and crossing Shanxi, Shaanxi, and Gansu provinces. On 28 September 1908 the expedition team left Taiyuan moving northwest, crossed the Yellow River, and passed through Jiao and Lin counties. They then passed through Jiazhou (present-day Jia county) and arrived at Yulin city; crossed over the Wuding River that passes through Mizhi county and Suide prefecture; and then crossed Qingjian county and Yanchuan county to Yan'an prefecture. They then passed through Ganquan county and followed the Luo River to Li prefecture.

At Li prefecture, the expedition team split into two, with one team traveling through Heshui county, Qingyang prefecture, Zhenyuan county, Guyuan prefecture, and Jingning prefecture to Lanzhou. The other team left Li prefecture and traveled south through Luochuan county, Tongguan county, Yao prefecture, and Sanyuan county. They crossed over the Wei River to Xi'an, then traveled through Xianyang county, Liquan county, and Gan, Fen, and Jing prefectures towards Lanzhou to meet up with the other team. On the way back from Lanzhou to Taiyuan, the expedition team remained mostly separated, following the aforementioned route. In September 1909, they returned to Taiyuan and Beijing.

Details of the Trek from Taiyuan to Lanzhou
The Clark expedition conducted surveys, made observations, and took measurements in the Taiyuan region for approximately two months. On 28 September 1908 they left Taiyuan; crossed Gujiao, Mo'er Mountain,[13] and Lin county; then they crossed the Yellow River, entered Jia subprefecture of Shaanxi province, and moved north to Yulin city. They then conducted surveys in the border areas of Yulin, along the Great Wall, and in the southern Ordos Desert for approximately one month. On 27 November 1908 Clark sent Grant and Cobb to Xi'an from Yulin[14] and sent a telegraph

to Beijing asking for a transfer of funds. Cobb was then sent to Shanghai from Xi'an, and then returned to Europe. Grant collected the new funds in Xi'an, traveled north, and arrived at Yan'an prefecture on 28 December, where he met up with the main team that had gone south from Yulin earlier. The complete expedition team stationed itself in Yan'an and conducted investigations over forty days.

Clark and Sowerby led the first team and followed a route from Yan'an to Xi'an then to Lanzhou. Douglas, Grant, and Ali lead the second team on the route from Yan'an to Qingyang then to Lanzhou. The main reason that the expedition split in to two groups at this time was to gain an understanding of several parts of the Loess Plateau.

On 28 January 1909 Clark and Sowerby left Yan'an with three servants, one mule caretaker, one horse caretaker, and a convoy of mules and horses. On 5 February they arrived in Xi'an and began to make meteorological observations and collect animal samples. On 8 February Clark departed Lintong, passed through Luoyang, Zhengzhou, and Hankou on his way to Shanghai to receive supplementary equipment, including bullets, tents, and burners purchased in Europe. Sowerby, stationed in Xi'an, collected samples of mammals and birds along the border of Wei

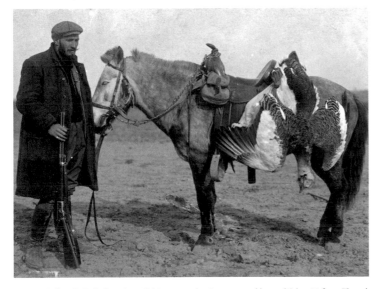

Fig. 29 Arthur de Carle Sowerby with his pony and a sixteen-pound bustard (plate 23 from *Through Shên-kan*)

River and in the foothills of the northern Qin peaks (fig. 29).[15] Approximately two weeks later, Sowerby received a telegraph from Shanghai sent by Clark. He then left Xi'an, passed through Luoyang and Zhengzhou, and headed to Hankou by train to meet with Clark. On 24 April the two returned to the city of Xi'an. On 6 May they left Xi'an and traveled towards Lanzhou. They passed through Xianyang, Liquan, Qianzhou, Yongshou, Fenzhou, and Changwu to enter Gansu province. Crossing Jing subprefecture, Pingliang prefecture, Jingning subprefecture, and passing through Huining, and Anding,[16] they arrived in Lanzhou on 24 May—a journey that took nineteen days to complete.

On 30 January 1909 Douglas, Grant, Ali, and the grooms brought most of the instruments and supplies from Yan'an, and traveled west via a route that most Western expedition teams did not use. They started this leg of the expedition in Li subprefecture, then passed through Heshui, Qingyang, Zhenyuan, Jingning, Huining, and Anding in Gansu province, and arrived in Lanzhou on 6 April, which took sixty-seven days.[17] On 24 May the two teams met in Lanzhou. The two groups had been separated for 116 days.

After the investigations in Lanzhou, the expedition moved southward.[18] On 20 June 1909 Sowerby and the servants departed Lanzhou first, accompanied by two Chinese soldiers. Hazrat Ali ventured out with two Chinese assistants to conduct additional surveying measurements. When Sowerby and his group returned to the main camp, he received the sad and troubling news that Hazrat Ali had been killed.[19] Following this incident, Douglas, Grant, Clark, and Sowerby fought with the locals, who injured two members of the expedition team. The expedition team members in turn killed one of the locals and injured two others. Because of this unfortunate turn of events, the team first returned to Lanzhou. The British and American ambassadors then demanded that they return to Taiyuan, and finally to Beijing.

On 2 July Clark and Douglas departed from Lanzhou, collected their equipment, and traveled through Xi'an, Luoyang, and Zhengzhou. After four weeks, they arrived in Beijing. On 15 July Grant and Sowerby left Lanzhou, with fifty mules carrying all their equipment and specimens, and passed through Jingning, Guyuan, Zhenyuan, and Qingyang. They entered Shaanxi; passed through Lizhou,

Table 1. Notable Western expeditions on the Loess Plateau in the late Qing dynasty (1870–1911)

Date	Nationality	Explorers/ Expedition	Route	Region of Activity
1870 and 1871	German	Freiherr von Ferdinand Richthofen	Departed from Guangzhou; passed through Hunan, Sichuan, and Henan, to Shanxi; passed Zezhou, Lu'an, and Qinzhou to reach Taiyuan; went through Baoding to arrive in Beijing.	Central and southern Shanxi (1870)
			Departed from Beijing; headed to Tong Pass via Zhangjiakou, Datong, and Taiyuan; then passed through Xi'an, Hanzhong, Chengdu, and Xuzhou to reach Shanghai along the Yangtze River.[20]	Shanxi, Guanzhong (1871)
1877–80	Austro-Hungarian	Baron Szechenyi's Expedition	Departed from Shanghai; passed through Hankou, Shangzhou, Xi'an, Qianzhou, and Fenzhou to enter Gansu; then crossed over Pingliang, Lanzhou, and Suzhou to Xining; traveled through Sichuan and Yunnan and returned to Europe via Burma and India.[21]	Gansu, Shaanxi
1887	British	Mark Bell	Departed from Beijing; passed through Baoding and Taiyuan; entered Tong Pass and headed northwest through Xi'an; passed through Pingliang, Lanzhou, and Suzhou into Xijiang, and further into Kashgar.[22]	Central and southern Shanxi, Shaanxi, Gansu
1904	American	Carnegie Expedition	Departed from Beijing; passed through Baoding and reached Wutai Mountain; headed south to Taiyuan and entered Tong Pass; passed through Xi'an, Siquan, over Mount Wu, and Yichuan; and reached Shanghai along the Yangtze River.[23]	Shanxi, Shaanxi
1906	British	C. D. Bruce	Departed from Kashgaria; crossed into Xinjiang, Gansu and Lanzhou, Qingyang; Ganquan, Yan'an in Shaanxi, then to Fengzhou, Taiyuan of Shanxi province, and arrived in Beijing through Baoding.[24]	Gansu, northern Shaanxi, and central Shanxi
1907–8	British	Duke of Bedford	Departed from Taiyuan; traveled westward to Yan'an, then entered the Ordos Desert, and reached Taiyuan from Ningwu.[25]	Central and northern Shanxi, northern Shaanxi
1911–2	British	H. F. Wallace	Departed from Shanghai; passed through Hankou and Zhengzhou; entered Tong Pass; then traveled through Xi'an, Fengxiang; Yaozhou, Lanzhou, Suzhou, and Xinjiang.[26]	Shaanxi and most of Gansu

Ganquan, Yan'an, Suide, and Wubao; and went into Shanxi via Liulin, Yongning, and Fenzhou. After a journey of fifty-five days, they arrived in Taiyuan on 8 September,[27] where they sold the mules and horses and packed the samples into crates. On 12 September the remaining expedition team members disbanded, which marked the formal completion of the Clark expedition in northern and western China.

Comparison with Other Foreign Expeditions of the Same Period

Before the Clark expedition, several Western expedition teams and explorers had carried out cartographic activities, specimen collecting, and geological and commercial surveys crossing various regions of the Loess Plateau (table 1). These expedition teams all followed routes through the hinterland of the Loess Plateau, with the exception of the British C. D. Wallace team, which headed to Beijing from Leh (a southern town of Kashgaria) via Lanzhou, Yan'an, and Taiyuan. Although Wallace investigated the natural and geographical conditions on his trip, the scope of his exploration cannot be compared to Clark's. The Clark expedition was the most comprehensive in terms of distance covered, regions explored, and subjects investigated.

Each expedition team had its own focus. The German geographer Richthofen and the American Carnegie team focused on geography and geology. The Austro-Hungarian Count Szechenyi and the British officers Mark Sever Bell and C. D. Bruce investigated geography and commercial roads; the British Duke of Bedford and H. F. Wallace focused on collecting animal samples. All in all, the Clark expedition was more comprehensive than any of these because it incorporated both natural and cultural studies.

Achievements of the Clark Expedition

Between May 1908 and September 1909, the Clark expedition team traveled approximately 3200 kilometers in central and northern Shanxi, central and northern Shaanxi, eastern and southern Gansu, as well as present-day southern Ningxia, and western Henan. The expedition resulted in significant scientific achievements, including zoological sample collection, map creation, meteorological observations, geological surveys, photo documentations, and the observation of both natural and cultural landscapes.

One of the main tasks of the Clark expedition team was to collect zoological samples from the Loess Plateau and the northern foothills of the Qin peaks. Similar to the Carnegie expedition experience, Sowerby put an emphasis on collecting samples of mammals, amphibians, reptiles, birds, and fish; Douglas mainly collected insects and parasites, such as fleas, ticks, mosquitoes, beetles, spiders, flies, and dragonflies.[28] The severe winter conditions in the winter and droughts in the summer limited the number of samples of birds, reptiles, and fish that were able to be collected.

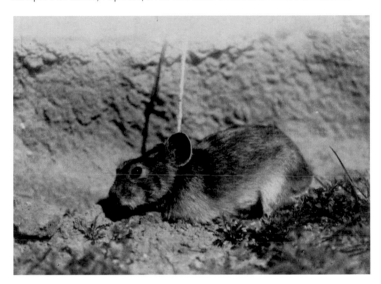

Fig. 30 Pika, *Ochotona annectens* (plate 52 from *Through Shên-kan*)

To collect zoological samples, Sowerby and others used hunting rifles and traps. They also purchased animal specimens from local hunters and hired locals to dig holes as traps.[29] The samples collected include animal skins, skulls, and skeletons. Sowerby also preserved snakes, frogs, lizards, and Chinese soft-shell turtles in alcohol. Butterfly samples were pressed flat and kept in special envelops. All samples were meticulously documented and their records contained information such as the name of the collector and location of collection, as well as quantity and sex of specimens.

The 250 mammal samples collected represent thirty-four species and sub-species. Zoologist Gerrit S. Miller of the Smithsonian Institution's United States National Museum (which later became the National Museum of Natural History) described five of these

species as new species.[30] Besides those animals commonly found in northern and western China, the Clark team also obtained samples of rare species, like the northern three-toed jerboa,[31] the semi-arboreal vormela (also known as tiger weasels),[32] vultures,[33] pikas (fig. 30),[34] gorals ,[35] and others.

Douglas, Grant, and Sowerby actively collected samples of invertebrates at Mt. Jiaocheng, Taiyuan prefecture, in northern Shaanxi. They found eleven types of insects, including beetles, bees, lice, flies, fleas, scorpions, mites, butterflies, moths, and lacewings.[36] The insect samples were given to the Royal Army Medical College at Millbank (Douglas's home institution) and then transferred to the British Museum to be assessed.

At the end of the expedition, 220 vertebrate specimens[37] were given to the Smithsonian in Washington, D.C.; sixteen cold-blooded vertebrates were identified and described.[38] In the summer of 1910, Sowerby and Miller brought a large collection of mammals to the British Museum to be identified and compared. Miller published articles, such as "A New Carnivore from China"[39] and "Four New Chinese Mammals,"[40] introducing mammals found in the Ordos Desert, Shanxi, and Shaanxi.[41]

Sowerby points out in Through Shên-kan that the mammals in the Ordos Desert, Shanxi, and Shaanxi had not been systematically studied before this expedition. The samples collected on the Clark expedition, as well as zoologists' identification and descriptions of these animals, helped biologists in the West to understand the diversity of species in the Loess Plateau. The reception of these specimens at Western museums and the resulting publications on these specimens sparked Western interest in continuing to research the region.

The Clark expedition's survey measured the longitude, latitude, and altitude of major towns and villages they visited and performed astronomical observtions to make maps of the region and routes. The responsibility for this work fell with Ali; after Ali's death, Sowerby and Grant took measurements and verified the data on their return journey.

Similar to the methods adopted by other Western expedition teams in China in the late Qing dynasty, the Clark team used a theodolite (a telescope mounted to a table that can measure angles) to measure longitude and latitude, and verified the measurements using the time difference between two locations marked on telegraph communications. They used triangulation to determine altitude, a quarter-inch plane table to draw maps, and often utilized a range counter to verify the data collected by the plane table.

Initially the team's survey had set a 720-meter baseline 3.2 kilometers north of Taiyuan, determined the longitude of Taiyuan through telegraphs sent to Tianjin, and then calculated the latitude through astronomical observations and data.[42] Once in Yan'an prefecture, Ali realized an error on the Taiyuan baseline and recalculated it. Along the path of the expedition, the team chose locations to calculate longitude and latitude, such as the southern gate of Yulin (see fig. 15) and the center point of the base of the bell tower in Xi'an.[43]

As mentioned earlier, prior to the Clark expedition a few Westerners had already conducted land surveys of the Loess Plateau. However, they used relatively simple systems of surveying. From 1877–90, the team led by Count Szechenyi investigated Shaanxi, Gansu, and other locations. They explored regions from Lanzhou prefecture to Pingliang prefecture via Anding county.[44] In 1887, the British military officer Mark Bell left Beijing to explore the Central Asian Trade Road, travelling over 5,600 kilometers through subprefectures in Shanxi, Shaanxi, and Gansu to reach Kashgar in Xinjiang. An account of his journey was published in 1890 with a partial road map of Shanxi, Shaanxi, and Gansu provinces.[45] In 1906, British explorer C. D. Bruch and an Indian surveyor left Leh, a town east of Kashmir, and headed to Beijing. An account of his journey was published in 1907, also with a road map.[46]

The maps made during the Clark expedition on the hinterlands of the Loess Plateau are more systematic, with more accurate routes that encompass a wider range of the plains. Detailed regional maps are included at the end of Through Shên-kan as well. These maps also show mountain ranges, the Great Wall, the Ordos Desert, and sub-branches of the Yellow River, as well as the towns, prefectures, and subprefectures that the Clark expedition visited.

The Clark expedition team had high standards regarding the accuracy of data collected. Clark states in Through Shên-kan that the latitudes "are always the mean of at least two observations,

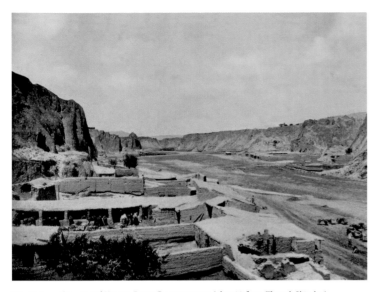

Fig. 31 Loess Canyon and Yingtao River, Gansu province (plate 39 from *Through Shên-kan*)

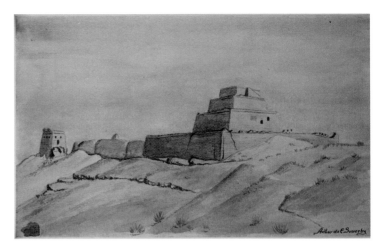

Fig. 32 Fort near Yulin, Ordos border, Shaanxi province (color plate from *Through Shên-kan*, 130)

and more often of from four to six. As the greatest variation never exceeded 8" [seconds], we think they can be taken safely as correct."[47] They determined longitude through three different methods: time difference between telegraphs, astronomical observations, and the plane table; the data collected from the latter being the most reliable. The team measured altitude in regions along the Yellow River within thirty miles with the triangular approach;[48] in the Shaanxi and Gansu region they utilized Aneroid and mercury barometers. In addition, verification of data collected on their return journey improved the accuracy of the initial data collected—something previous expedition teams had not achieved.

On 16 May 1908 the Clark team began making meteorological observations in Taiyuan and continued taking these measurements consistently as they traveled through the provinces of Shanxi, Shaanxi, and Gansu—all the way until the expedition's completion on 12 September 1909.[49] On the journey from Taiyuan to Lanzhou, meteorological observations were solely Douglas's responsibility. On the return journey, Sowerby and Grant were responsible. They took detailed notes on temperature (maximum, minimum, and average); humidity (maximum, minimum, and average); wind speed direction, and strength; rainfall amount (maximum and minimum); atmospheric pressure (a.m., p.m., average); and dust storms,

cloud layer, and thunder (time of occurrence). Daily entries of the observations on meteorology were included at the end of *Through Shên-kan*.[50]

Although no geologist accompanied the Clark expedition, Sowerby and other members of the team had some knowledge of geology. Before the Clark surveys were conducted, Sowerby analyzed and summarized the research results and viewpoints of American geologist Raphael Pumpelly,[51] German geographer Freiherr von Ferdinand Richthofen, and the Carnegie expedition of the Loess Plateau in order to better understand the areas through which they would travel.

The Clark expedition's findings added greatly to geological knowledge of the Loess Plateau. Sowerby pointed out that even though well-known geologists traveled in northern China, "the route taken by the present [Clark] Expedition seems to have been almost altogether through districts entirely new, so far as this science is concerned."[52] The regions west of Taiyuan in Shanxi and north of the Wei River in Shaanxi were two areas not explored by the Richthofen expedition but analyzed in depth by the Clark expedition.

The expedition's geological enquiry consisted of three objectives: the study of geological strata, mountainous regions, and lakes in central Shanxi and northern Shaanxi;[53] the investigation of natural resources in Ningxia region, such as coal and crude oil; and the

formation of the Loess Plateau (fig. 31). The third objective, which drew the most interest from Western academia, involved in-depth investigations of "burned earth," soil moved by wind, and soil moved by landslides. Observations made by the Clark expedition suggest that the Loess Plateau was formed by wind and yellow soil from the Gobi Desert rather than by lake sediments as earlier theories had proposed.[54]

The Clark expedition team took numerous photographs throughout the journey. Grant and Sowerby photographed people and animals, and Sowerby created many color drawings (fig. 32). Eighty-four images from the expedition were published in *Through* *Shên-kan*, including photographs, maps, drawings, and sketches. The subjects of the photographs include hunters, shepherds, government officials (fig. 33), guards, prisoners, castles, mountain passes, towns, villages, pagodas, and temples. The photographs of daily life include images of threshing wheat (see fig. 27), washing clothes, hunting, and fishing. Images taken for geological and geographical purposes include images of the high plains, deserts, mountainous regions, and valleys. The expedition also took photographs of wild animals, such as boars, northern three-toed jerboa, pika, and Chinese soft-shell turtles. The six color drawings include images of beacon towers on the Great Wall, cave dwellings, and

Fig. 33 Tao-t'ai of Guyuan (Ningxia province) with his secretaries and guard (plate 37 from *Through Shên-kan*)

Fig. 34 Gorges between Wucheng and Fenzhou, Shanxi province (plate 58 from *Through Shên-kan*)

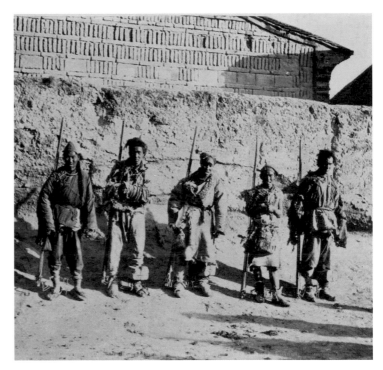

Fig. 35 Exiles in chains at Huining, Gansu province (plate 42 from *Through Shên-kan*)

the Yellow River. The expedition images reveal the natural and cultural landscape of the Loess Plateau at the end of the Qing dynasty, and thus have become valuable archival images.

The team made detailed and in-depth observations of the natural scenery along their route, including landforms (fig. 34), botany, animals, rivers, and lakes. These observations, documented in *Through Shên-kan*, offer a comprehensive overview of the natural conditions of the Loess Plateau region during that time. For example, the book describes birds spotted on the banks of the Wei River near Xi'an: "great flocks of geese were seen feeding on the fields of early wheat. . . . Here and there were small flocks of stately cranes, whilst in the irrigation canals and marshy rice fields were feeding numbers of Chinese ibises *(Nipponia nippon)* [crested ibis], pink, white, or grey."[55] The team also took notes on water quality, the depth and width of rivers, the direction of flow, and the geological conditions of the shores of the Fen, Yellow, Luo, and Wei Rivers. Landforms of the Loess Plateau, including plains, ridges, mounds, gullies, surface cuts, and landslides were also observed and documented.[56]

Through Shên-kan also documents population changes that resulted from long periods of war and natural disasters (fig. 35). During the twelve years of the Tongzhi emperor's reign (1862–73), most towns in Shaanxi and Gansu faced Uygur uprisings during which villages were burned down and populations decreased drastically. Land cultivation diminished or stopped completely, which allowed the native plants of the Loess Plateau to recover. Between 1876 and 1879, Shanxi and Shaanxi provinces suffered from a severe drought known as the "Three Year Drought." Towns and villages turned into ruins, with many dying of starvation.

The Clark expedition's observations and records of cultural heritage, commerce, technology, and customs further highlight its comprehensive and systematic approach. The Loess Plateau is considered to be one of the regions where China's civilization originated, and the team found cultural relics in many locations along their route. The Clark team observed the relics and their

Fig. 36 Cave temple (Song dynasty) at Yan'an, Shaanxi province (plate 18 from *Through Shên-kan*)

architectural form; interviewed monks, elders, and other local residents; and photographed a large number of historical ruins and architectural structures (fig. 36).

The Clark expedition made detailed records of the ruins of the Great Wall in Yulin (fig. 37), Buddhist temples in Yan'an, the emperors' tombs in Shaanxi, the forest of steles in Xi'an, Qinghua basin, Huayin temple, and the Big Buddha temple in Bin county (fig. 38). The Clark team not only compared sculptures of different

Fig. 37 Towers of the Great Wall north of Yulin, Shaanxi province (plate 13 from *Through Shên-kan*)

regions, but also compared sculptures throughout different dynasties, and thus concluded that "the T'ang temples are much higher, and contain fewer but larger figures; on the other hand the Sung temples have their walls lined with innumerable little images of Buddha carved out of the rock."[57]

The Clark expedition meticulously recorded in photographs and narrative the character of numerous villages, towns, counties, prefectures, and provincial capitals along their route. For example, the layout of Jiangtaipu village located on the east shore of Hulu River, thirty kilometers southeast of Xiji county capital of Ningxia, is noted in *Through Shên-kan:* "This consists of two sections, each surrounded by a high and crenellated wall. The larger boasts of two gates and a moat, and one long broad street running from gate to gate with the houses on each side symmetrically arranged."[58]

The descriptions of towns and villages are thorough, including details like position, layout, population, missionary presence, commerce, and postal and telegraph services. They described Lin in Shanxi as "a well built town, surrounded by a wall in an unusually good state of preservation, contains a population of about 3000. The Roman Catholics have established here a Mission station, where a priest resides. The place owes its prosperity mainly to the fact that it forms the mart and distribution centre for a large stretch of country."[59] They also described the central cities in this region, such as Taiyuan, Yulin, Yan'an, Xi'an, Lanzhou, and others, in detail, explaining features like moats, urban layouts, street architecture, trade, and population distribution.

In various parts of northern Shaanxi, the Clark team made detailed notes on living styles unique to the Loess Plateau region. Observations on some unique dwellings include the following: "The surfaces of the plateau were under cultivation, but nowhere could any villages be seen. This was explained, when it was discovered that the villages were either built on the sides of the smaller ravines, or formed by extensive excavations below the surface level. In the latter case each dwelling would consist of one large square pit, twenty ot thirty feet deep, and forming the courtyard, from which opened deep cave-rooms, occupied by the members of the family and their livestock (fig. 39)."[60] The expedition team also noticed that the villages above ground were larger and more

Fig. 38 Colossal Buddha, Da fo si, Bin Xian, Shaanxi province (plate 29 from *Through Shên-kan*)

impressive, but isolated and fewer in number.

On the southern borders of the Ordos Desert region, north of Yulin prefecture, the expedition team studied "heaven burials"—a Mongolian custom where the corpse is placed in the wild desert so it can be eaten by birds and beasts in order to go to heaven.[61] The understanding of burial customs throughout the area furthered the Clark expedition's understanding of beliefs, religions, and cultures in the Loess Plateau region.

The Clark expedition team also recorded observations of the different ethnicities, belief systems, and professions they encountered (fig. 40). Their anthropological observations of people the mountainous regions of Taiyuan in Shanxi concluded that: "The natives, though poor, are healthy-looking; the men are stalwart and well-built"[62] While traveling through Jingning subprefecture, the expedition observed the following distinction between the Han Chinese and Uighurs: "whenever the ordinary Chinese tilled the soil, the best land was devoted to the cultivation of the poppy; whereas the Mohammedans [Uighurs] used all their land for cereals, hemp, and other useful products."[63] The team also surveyed commodity prices, transportation by land and water, diseases, salt production, and crude oil extraction.

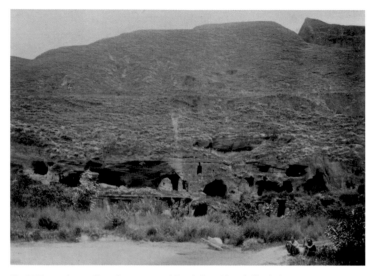

Fig. 39 Deserted cave village, Gansu province (plate 45 from *Through Shên-kan*)

Summary of Achievements of the Clark Expedition and Conclusions Between 1908 to 1909, the Clark expedition team spent over 480 days in Shanxi, Shaanxi, and Gansu provinces, traversed over 3200 kilometers, made meteorological observations and measurements, charted road maps, collected animal samples, conducted geological surveys, and photographed the area. This resulted in an in-depth and systematic study of the natural and cultural conditions of the Loess Plateau. The team implemented Western scientific methods and approaches to collect and analyze data. Their documentation and research covered several fields, including geography, geology, biology, meteorology, and botany. *Through Shên-kan* became the most comprehensive and systematic survey of the Loess Plateau in the late Qing dynasty. Overall, their scientific documentation of the natural, cultural, and geographic conditions of the region has become a valuable record on the environmental changes and living conditions of the region in the late Qing dynasty.

The Clark team was different from the other Western expedition teams of the same era in many respects. Clark solely funded and guided his team while governments or organizations funded the others. The data that the Clark expedition team compiled had an academic focus, concentrating on natural sciences, anthropology, and sociology. With the exception of collecting a few animal samples, there is no evidence that the Clark expedition team acted irresponsibly.

They did not rob or destroy cultural relics or hunt rare species—activities that were common among other Western expedition teams.

As previously stated, before the Clark expedition, the German geographer Richthofen, the British Duke of Bedford, and the American Carnegie expedition had all conducted specific scientific surveys in the Shanxi, Shaanxi, and Gansu regions. However, the expedition route chosen by Clark and the areas covered largely supplemented the incomplete data from previous expeditions. The Clark expedition team made significant zoological, cartographic, meteorological, and geological research gains as a result of their unique route.

Members of the Clark expedition were experienced experts who carried with them a large number of advanced scientific instruments. Although they did not proceed to Tibet as planned and had to return half way through the journey, they were able to retrace their original route and verify the data they collected in different seasons. The Clark expedition data is more accurate than data from expeditions that followed circular routes.

The team made daily meteorological observations, recording temperature, atmospheric pressure, rainfall, wind direction, wind strength, humidity, and other key factors in order to ensure a systematic methodology of data collection. The Clark expedition collected an extensive and accurate body of data, the most valuable source for studying the meteorological conditions of the Loess Plateau region in the late Qing dynasty, and created a valuable historical record for future study.

Since the Qing Ministry of Foreign Affairs gave Clark permission to travel and research in western China, local governments aided the team in some of their activities like surveying and cartography by offering them protection and telegraph communication. Although accounts of Ali's death vary, its occurrence reflects the complex attitudes of the Chinese people toward foriegners encountered by the expedition and the cultural conflicts at that time between China and the West. Although the conflict after Ali's death between the Clark expedition team members and the local farmers in the mountainous region south of Lanzhou was accidental, it reflected the Western expedition's colonial attitude—a shared characteristic of Western expeditions in China at the end of the Qing dynasty.

Fig. 40 Woman posing with potted plants (possibly in Yulin), (plate 12 from *Through Shên-kan*)

Like other expedition teams, the Clark team carried arms, which although legal, eventually led to conflict. The fight following Ali's death, which resulted in the death of two Lanzhou farmers, revealed the Western expedition teams' tendency to use violence. The ambassador overlooked the death of the Lanzhou farmers and demanded that the Gansu government compensate the expedition team. Furthermore, he requested the replacement of the governors of Shanxi and Shaanxi, reflecting the colonial attitude in the weakened Qing state. Conflicts between Western expedition teams and local residents were frequent, due to habitual differences in cultural customs, as well as to the West's forcible occupation of the eastern coast and rivers, which included placing warships on the Yangtze River. Thus, the Chinese had a generally negative impression of foreigners. It was difficult, if not impossible, for citizens to distinguish between foreigners conducting academic research from those occupying land, plundering resources, and stealing cultural relics.

The review of *Through Shên-kan* published in the *Bulletin of American Geographical Society* in 1915 states:

> the record of the territory traversed . . . is most complete, . . . the route map is drawn with scrupulous care, the astronomical determinations of the position are all that could be desired, and the zoölogical collections have all been monographed by competent specialists. Few expeditions of recent adventure have accomplished so much in so short a time, still fewer have presented the results in such satisfactory form.[64]

Certainly, the conflict that occurred with local residents in the mountains to the south of Lanzhou tainted the success and achievement of the Clark expedition in China. Overall, an objective evaluation of the Clark expedition in terms of its academic contribution during a historical period of transition validates its significance.

Notes

This essay was originally published in *A Collection of Theories on Chinese History and Geography*, no. 4, 2008 and again in the author's Mandarin critical edition of *Through Shên-kan* (Shanghai Scientific and Technological Literature Publishing House Co., Ltd., 2010) as Appendix 12, 271–89. The text has been translated and edited for this book.

1. Zhu Zongyuan, *Research and Studies on the Geographical Environment in Northwest China by European and American Scholars from the Eighteenth Century, Resources and Environment in Drought Areas* (Beijing: Science Press, 1999), no. 3. This text identified and described explorers from Russia, Germany, Britain, and America, but did not mention the Clark expedition. See also Luo Guihuan, *Modern History on Identified Chinese Biology* (Jinan: Shandong Education Publications, 2005), 246–47. Although the Clark expedition is mentioned, the information included about the expedition is limited.

2. Robert Sterling Clark and Arthur de C. Sowerby, *Through Shên-kan: The Account of the Clark Expedition in North China, 1908–9* (London: T. Fisher Unwin, 1912).

3. Clark and Sowerby, *Through Shên-kan*, 2.

4. Luo Guihuan, *Modern History on Identified Chinese Biology*, 246.

5. W.R.C., "Researches in Northern China," review of *Through Shên-kan* by Robert Sterling Clark and Arthur de Carle Sowerby, *The Geographical Journal* 41, no. 3 (March 1913): 276.

6. Keith Stevens, "Naturalist, Author, Artist, Explorer and Editor, and Almost Forgotten President: Arthur de Carle Sowerby, 1885–1954, President of the North China Branch of the Royal Asiatic Society, 1935–1940," *Journal of the Hong Kong Branch of the Royal Asiatic Society* 38 (1998): 125.

7. Clark and Sowerby, *Through Shên-kan*, 2.

8. Ibid., 2–3.

9. Stevens, "Naturalist, Author, Artist, Explorer and Editor," 125.

10. Clark and Sowerby, *Through Shên-kan*, 5.

11. Clark and Sowerby, *Through Shên-kan*, 135.

12. Ibid., 2.

13. According to *Through Shên-kan*, Mo'er Mountain has an altitude of 2833.4 meters.

14. Clark and Sowerby, *Through Shên-kan*, 22.

15. Ibid., 33.

16. Ibid., 58–59.

17. Ibid., 55.

18. Ibid., 68.

19. There are multiple accounts of Ali's death: p. 67 of *Through Shên-kan* refers to a story told by the villagers about a crowd driving a runaway

cow, which caused Ali to think he was being chased after while taking measurements. He fled, in panic, and then fell off a cliff. Another version is that locals believed Ali's measurements and surveys in the region were witchcraft that would bring drought, so they killed him. See Stevens, "Naturalist, Author, Artist, Explorer and Editor," 125.

20. Freiherr von Ferdinand Richthofen, *Baron von Richthofen's Letters, 1870–1872* (Shanghai: Printed at the *North China Herald* Office, 1903), 155–61.

21. Baron F. von Richthofen, "Count Széchenyi's Travels in Eastern Asia," review of *Die wissenschaftlichen Ergebnisse der Reise des Grafen Béla Széchenyi in Ostasien 1877–1880*, by Count Széchenyi, *The Geographical Journal* 3, no. 4 (April 1894): 311–18.

22. Mark S. Bell, "The Great Central Asian Trade Route from Peking to Kashgaria," *Proceedings of the Royal Geographical Society and Monthly Record of Geography* 12, no. 2 (February 1890): 57–93.

23. J. W. G., "The Carnegie Expedition to China," review of *Research in China*, by Bailey Willis et al., *The Geographical Journal* 34, no. 1 (July 1909): 73–74.

24. C. D. Bruce, "A Journey across Asia from Leh to Peking," *The Geographical Journal* 29, no. 6 (June 1907): 597–623.

25. Melville B. Anderson, "Malcolm Playfair Anderson," *The Condor* 21, no. 3 (May/June 1919): 115–19.

26. Harold Frank Wallace, *The Big Game of Central and Western China, Being an Account of a Journey from Shanghai to London overland across the Gobi Desert* (New York: Duffield and Co., 1913).

27. Clark and Sowerby, *Through Shên-kan*, 70.

28. Clark and Sowerby, *Through Shên-kan*, 79.

29. Ibid., 72.

30. Ibid., 95.

31. Ibid., 83.

32. Ibid., 84.

33. Ibid., 82.

34. Ibid., 87.

35. Ibid., 94.

36. Ibid., 186.

37. Ibid., 79, 171.

38. Ibid., 109.

39. Gerrit S. Miller, "A New Carnivore from China," *Proceedings of the United States National Museum* 38 (August 1910): 385–86.

40. Gerrit S. Miller, "Four New Chinese Mammals," *Proceedings of the Biological Society of Washington* 24 (February 1911): 53–55.

41. Clark and Sowerby, *Through Shên-kan*, 80.

42. Ibid., 131.

43. Ibid., 44.

44. Baron von Richthofen, "Count Széchenyi's Travels in Eastern Asia."

45. Bell, "The Great Central Asian Trade Route," 57–93.

46. Bruce, "A Journey across Asia," 598.

47. Clark and Sowerby, *Through Shên-kan*, 132.

48. For example, obtaining data by utilizing the plane table perpendicular to the ground.

49. Clark and Sowerby, *Through Shên-kan*, 135.

50. Ibid., 219.

51. Raphael Pumpelly, *Across America and Asia: Notes of a Five Years' Journey around the World, and of Residence in Arizona, Japan, and China* (New York: Leypoldt & Holt, 1870).

52. Clark and Sowerby, *Through Shên-kan*, 115.

53. Ibid., 116–19.

54. Ibid., 129.

55. Ibid., 89.

56. Ibid., 128.

57. Ibid., 53.

58. Ibid., 72.

59. Ibid., 12.

60. Ibid., 36.

61. Ibid., 97.

62. Ibid., 10.

63. Ibid., 71–72.

64. William Churchill, review of *Through Shên-kan: The Account of the Clark Expedition in North China, 1908–9,* by Robert Sterling Clark and Arthur de C. Sowerby, *Bulletin of the American Geographical Society* 47, no. 1 (1915): 62.

ROUTE OF THE CLARK EXPEDITION
THROUGH SHANSI, SHENSI, AND KANSU.
1908-9.

Reduced from Plane-table Survey by Hazrat Ali, Survey of India.

Scale 1:633,600 or 1.014 Inches to 16 Miles.

Meanings of some common place-name terminations:

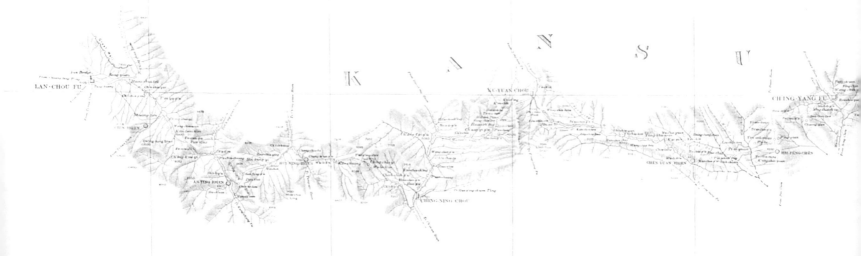

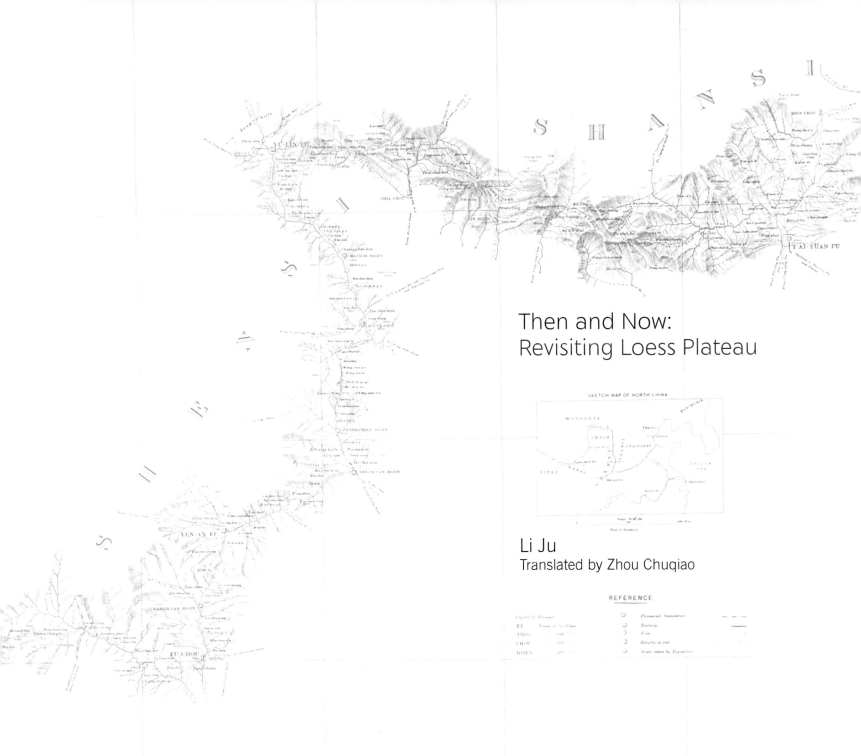

Then and Now:
Revisiting Loess Plateau

SKETCH MAP OF NORTH CHINA

Li Ju
Translated by Zhou Chuqiao

REFERENCE

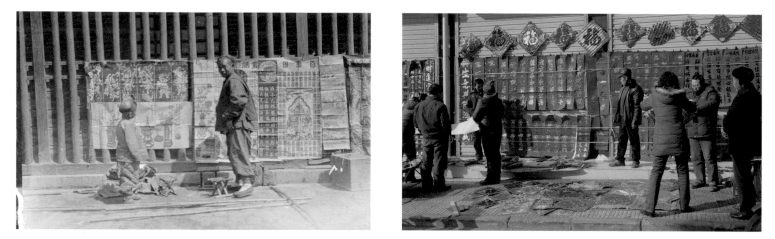

Street vendor with child and prints, Suide, Shaanxi province, c. 1909, and a stall selling spring festival poems in Suide, Shaanxi province, January 2009

More than a decade ago, I started to pay attention to old photographs, particularly images of the Great Wall. Working with a few friends who share the same interest, we collected old images, analyzed their location, and then retook new images. By comparing the images, we observed the changes time had wrought on these ancient places.

In April 2008, I discovered a group of old photographs of Yulin, a city in the northern Loess Plateau, taken by the Clark expedition in 1908–9. The group included not only images of the wall, but also scenes of nearby cities, fortresses, gates, mountain beacon towers, and animals. I found these images to be vivid and captivating—a portfolio of the landscapes of northwestern China and a record of the humanity, geology, biology, and sociology of the region.

Intrigued by these photographs, I sought out a copy Sterling Clark's book *Through Shên-kan: The Account of the Clark Expedition in North China, 1908–9*. Reading the familiar names of places I had once visited and those that I had always longed to see sent my heart flying. After reading it more than five times, the book led me on this extraordinary path: in November 2008, departing from Beijing, I started my own journey through *Shên-kan* (including the modern provinces of Shaanxi and Gansu and much of the Loess Plateau). Over the next few years I took three more journeys, following the same route as the expedition, confirming the locations in the original photographs, and shooting contemporary comparative photographs. When I stood in the same

places as the earlier explorers, looking through the camera's viewfinder at the landscape and pressing the shutter button, I felt I was conversing with the expedition team.

The Clark expedition experienced the beauty of the Lüliang Mountains, the spectacular canyons of the Yellow River, the desolate Ordos Desert, and the magnificent Great Wall. As I traced this route, lingering questions motivated me onwards: What made the Clark expedition interested in the Loess Plateau? What has happened to the landscapes recorded in the old images? After wars and turmoil, natural disasters and famine, how have the lives of the people in these places changed? What about the fate of the exquisite historical relics? Are wild animals still living in these areas?

By following in the footsteps of the Clark expedition and rephotographing views originally captured by the expedition team, my aim was to address some of these questions and contribute to this collective anthropological record that can be called a visual encyclopedia of the Loess Plateau across time. When comparing then-and-now pairs of images, viewers get an intuitive and vivid understanding of the historical appearance of northwestern China and the dramatic changes that have occurred over the past century—a comparative visual essay on the passage of time and the endurance of culture. The Clark expedition photographs give texture to our understanding of history in this region, and my new photographs bear witness to both continuity and change along China's frontier.

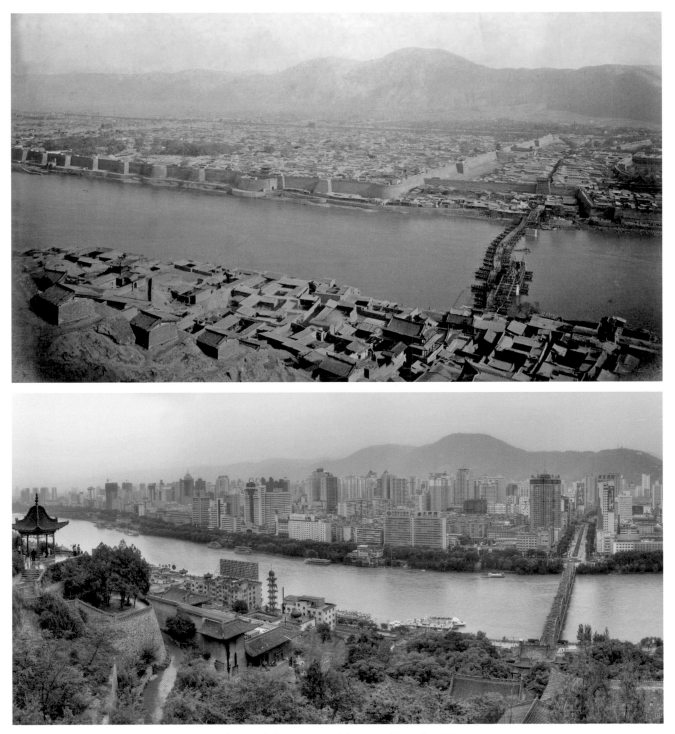

View from Baita Mountain across the Yellow River to Lanzhou, capital of Gansu province, May 1909 and September 2009

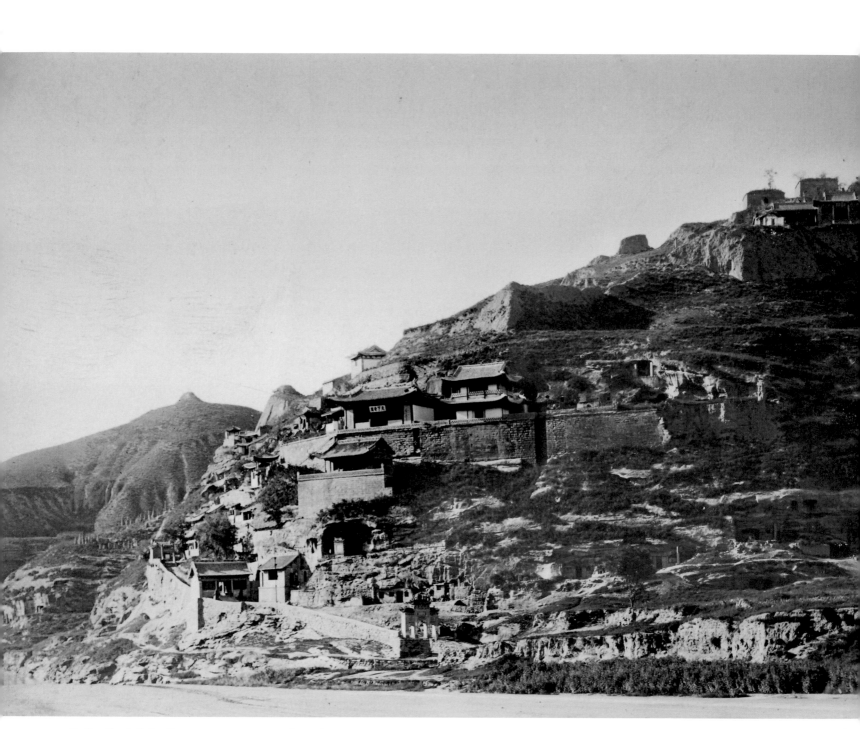

Qingliang Temple, Yan'an, Shaanxi province, August 1909 and November 2011

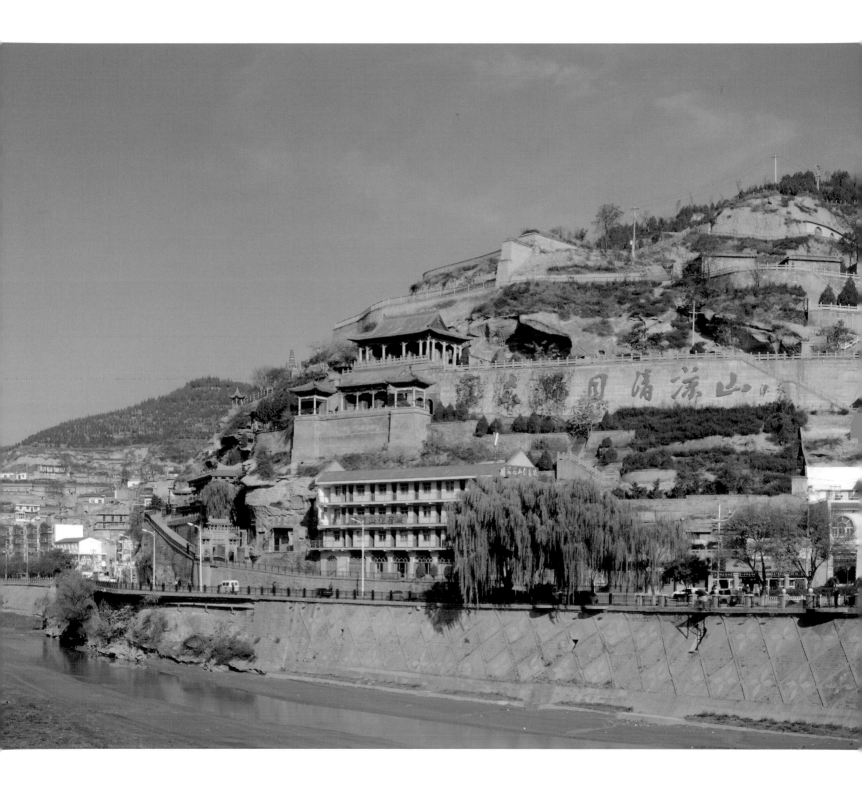

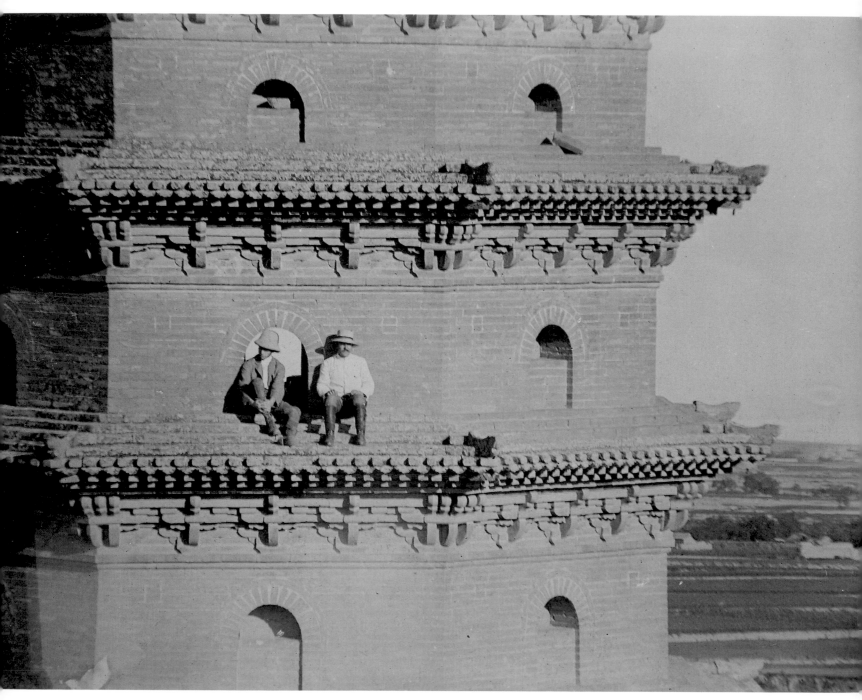

Wenfeng Pagoda, Yangzou Temple, Taiyuan, Shanxi province, May 1908 and November 2008

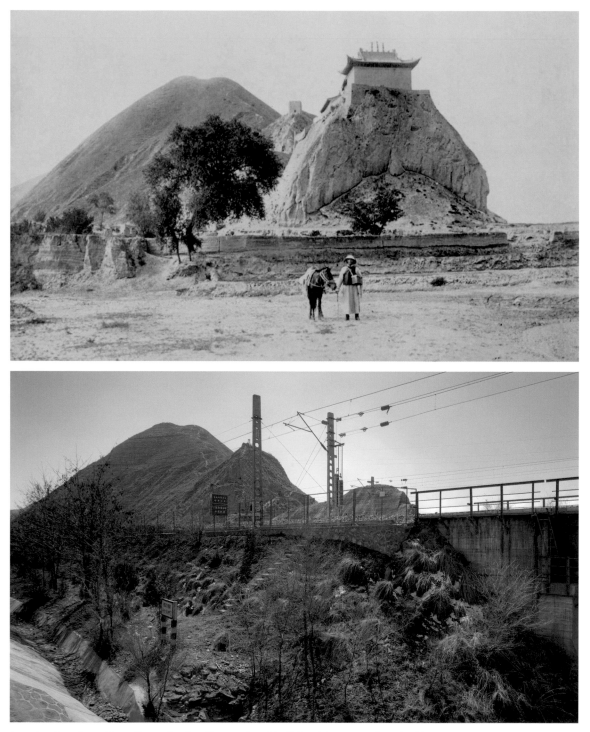

A temple on Loess Spur at Gancaodian near Lanzhou, Gansu province, July 1909, and the same site, September 2009

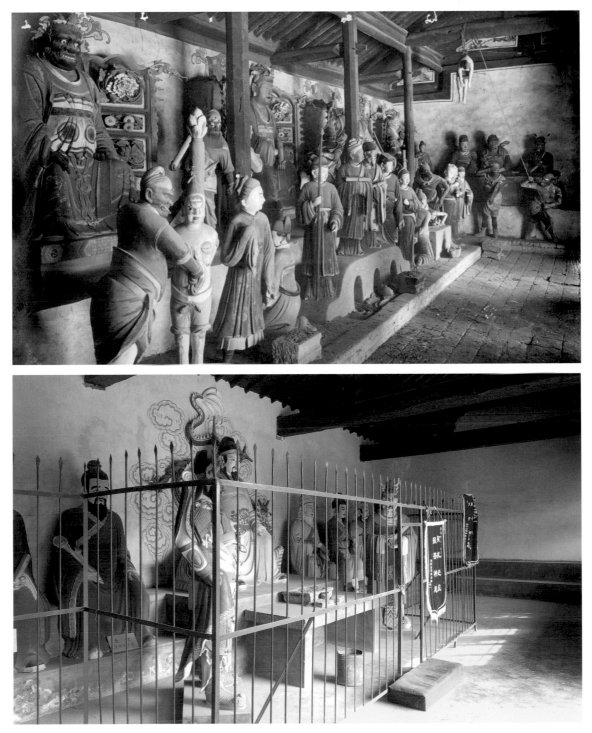

Representation of Buddhist hell in the Yao Wang Temple, Yan'an, Shaanxi province, December 1908 and c. 2009

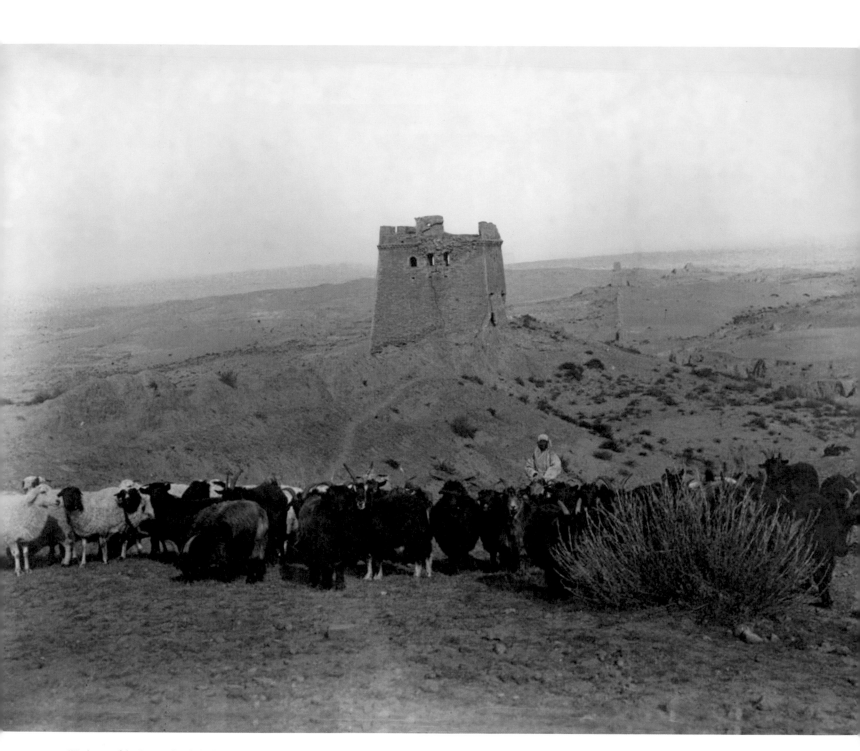

Watchtower of the Great Wall with shepherd and sheep in foreground near Yulin, November 1908, and the same site, April 2009

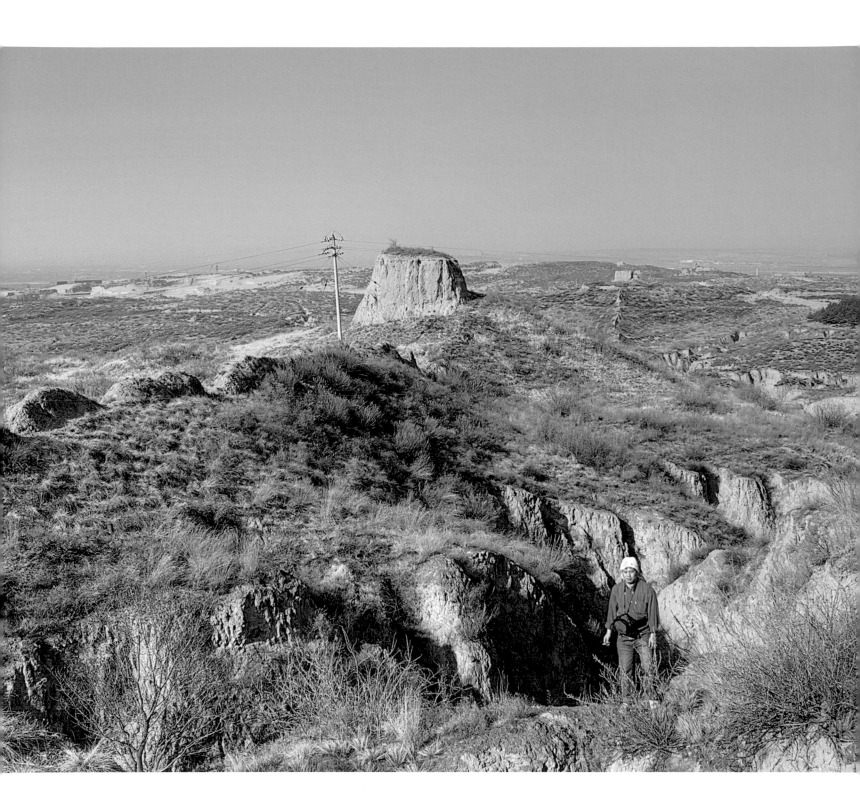

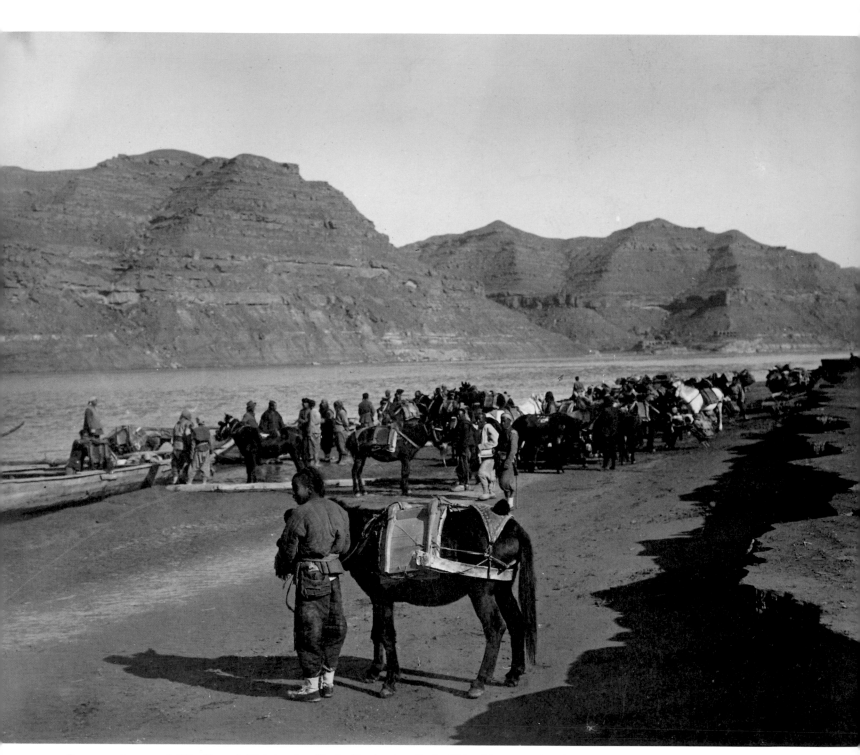

Caravan preparing to cross the Yellow River at the Niujiachuan ferry, Xingxian, Shanxi province, October 1908, and the same site, December 2008

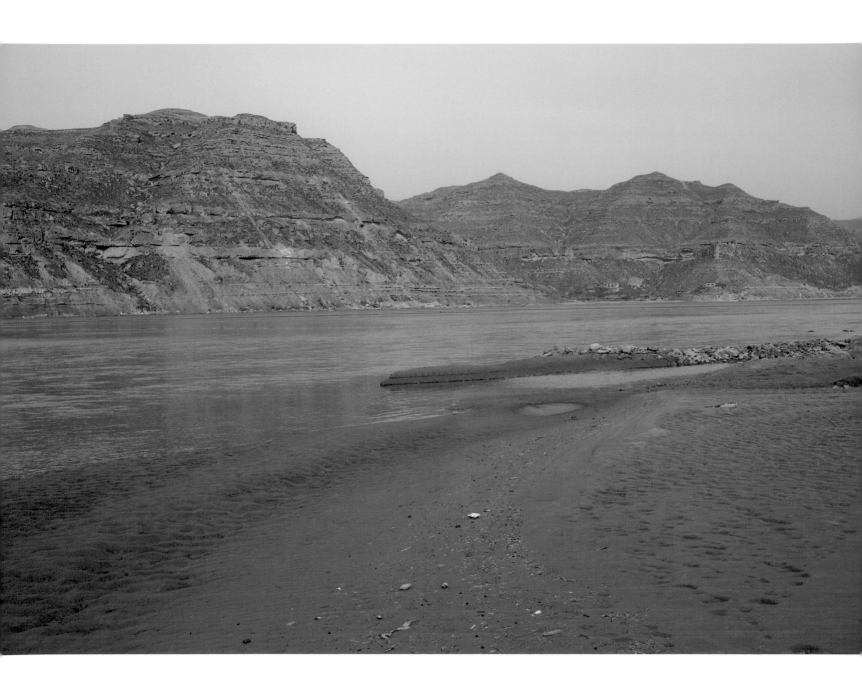

ROUTE OF THE CLARK EXPEDITION
THROUGH SHANSI, SHENSI, AND KANSU.
1908-9.

Reduced from Plane-table Survey by Harvial & Survey of India.

Scale 1 Inch to or 1·014 Inches to 16 Miles.

Meanings of some common place name terminations.

LAN-CHOU FU

K A N S U

PING-YANG FU

CHING YANG FU

CHING NING CHOU

CHEN YUAN HSIEN

Phantoms of the
Clark Expedition

Mark Dion

The Clark expedition through northern China in 1908–9 was a rigorously scientific exploration, collecting data in the disciplines of geology, meteorology, astronomy, cartography, botany, and zoology. The seriousness and significance of the expedition is particularly surprising when one considers that its organizer and leader, Sterling Clark, is today largely remembered as a collector and patron of fine art. The Clark expedition was in no way an exercise in the looting of Chinese cultural treasures; indeed, it stands in marked contrast to other expeditions of this period largely because of the cogency of its scientific makeup.

In the researching of the expedition history, what seems striking is the scarcity of the material culture of the expedition itself. This was a massive undertaking, involving dozens of pack animals, a large exploratory team, and a support staff of thirty persons. Such an expeditionary force required vast amounts of provisions and equipment, yet with the exception of a few precision instruments and significant biological and geological specimen collections, little material remains of such an ambitious endeavor. The Clark expedition is well represented textually in *Through Shên-kan*, the book that documents the journey and the data of various kinds produced. It includes a wealth of images, which have also been lost in their original glass negative form.

Phantoms of the Clark Expedition, a project at The Explorers Club in New York, highlights not only what Clark and his team took from China but also what they brought to the site of inquiry. Thus, the equipment and provisions to undertake such a complex tour are given a new importance that emphasizes the labor of the journey rather than the particular scientific results. In this way, the Clark team itself becomes the locus of an ethnographic investigation, an attempt to understand the cultural underpinnings of a distinct social group, based on their physical belongings. Needless to say, these materials gathered and interrogated are not exclusive to this particular expedition but rather are those shared by explorers globally. Certain objects, doubtlessly essential to exploration, are carefully reproduced as papier-mâché surrogates or specters of themselves. Some of these are arranged into tableaux of the expedition archetypes, such as the campfire, provision store, or the specimen. Others are arranged more indexically, a taxonomic grouping based on utility, for example. Objects in the exhibition oscillate between the general conditions and needs of all explorers and the particular goals, results, and follies of the Clark expedition itself.

Any consideration of a historical expedition strives to understand the difference between pernicious colonial expansion and scientific inquiry. In most cases, including the Clark expedition, the distinction between the two is too fine and too utterly entangled to discern. The specter of imperial exploration haunts both this exhibition and the halls of The Explorers Club as well.

All works by Mark Dion (American, b. 1961), are papier-mâché unless otherwise noted. Dimensions are given as height, width, and depth. For irregularly shaped objects, the dimension is given at its greatest point.

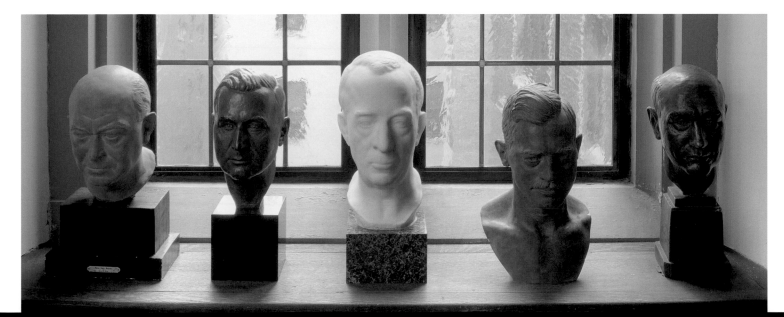

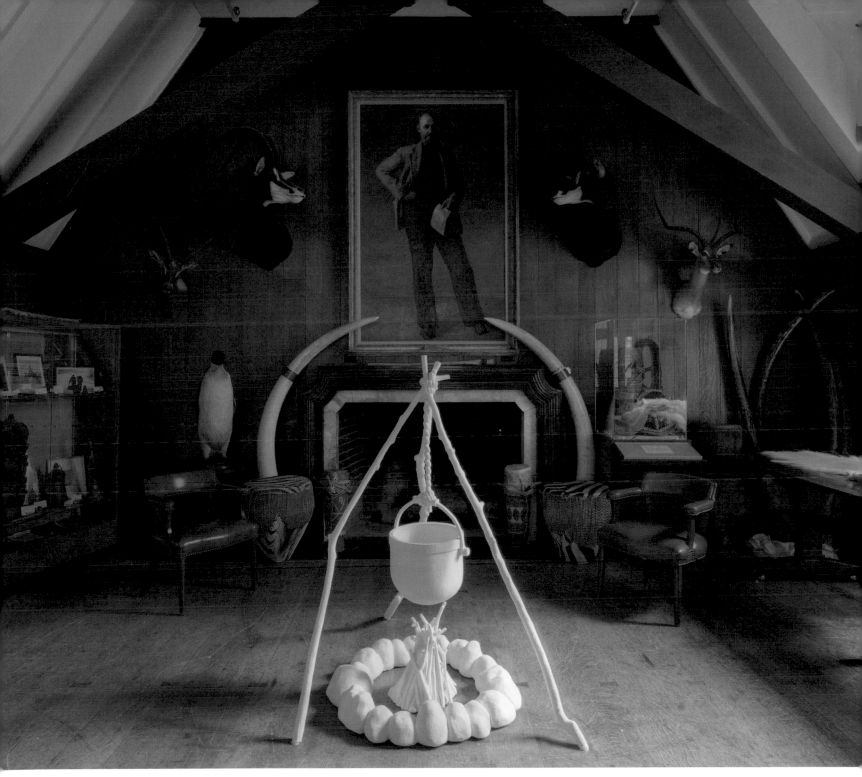

Above: Campfire—Clark Expedition, 2012 (56 x 64 x 40 inches)
Left: Busts of past members of The Explorers Club, with marble bust of Sterling Clark by sculptor Elie Nadelman (American, 1882–1946) placed among them by Mark Dion

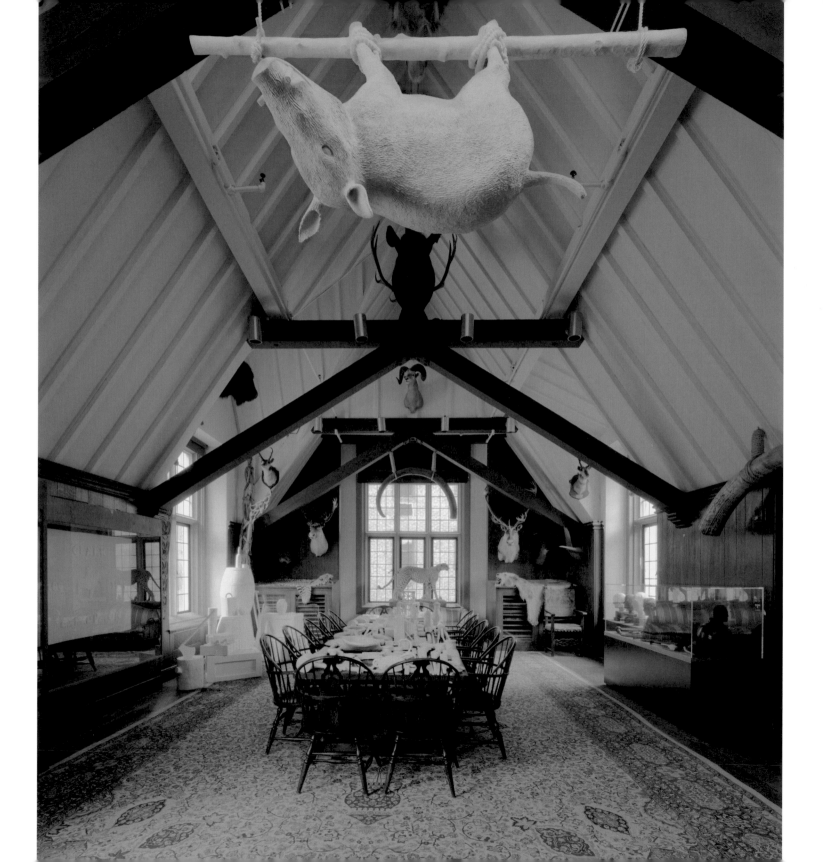

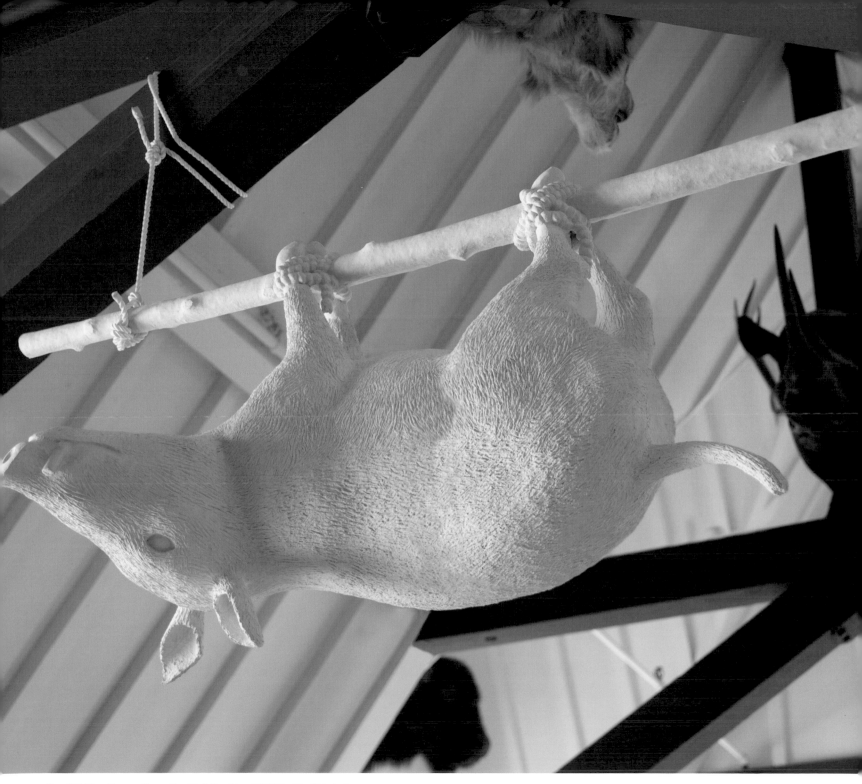

Above: Wild Boar Shot near Yen-an Fu—Clark Expedition, 2012 (31 x 71 x 20 inches)
Left: Fifth-floor Trophy Room at The Explorers Club, with Mark Dion's *Phantoms of the Clark Expedition,* 2012

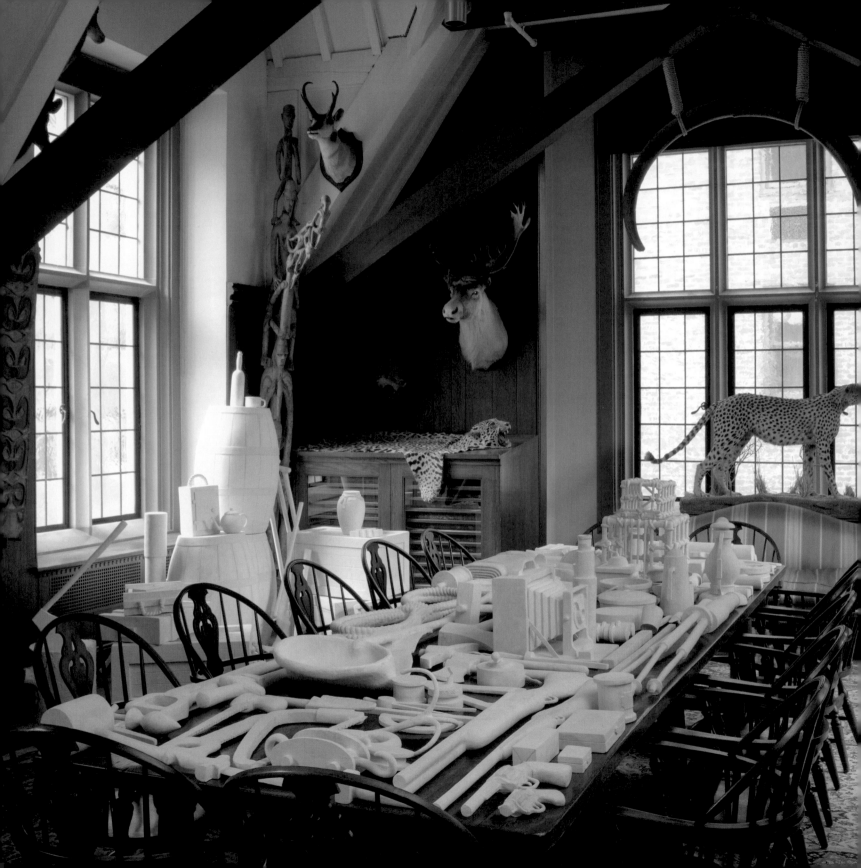

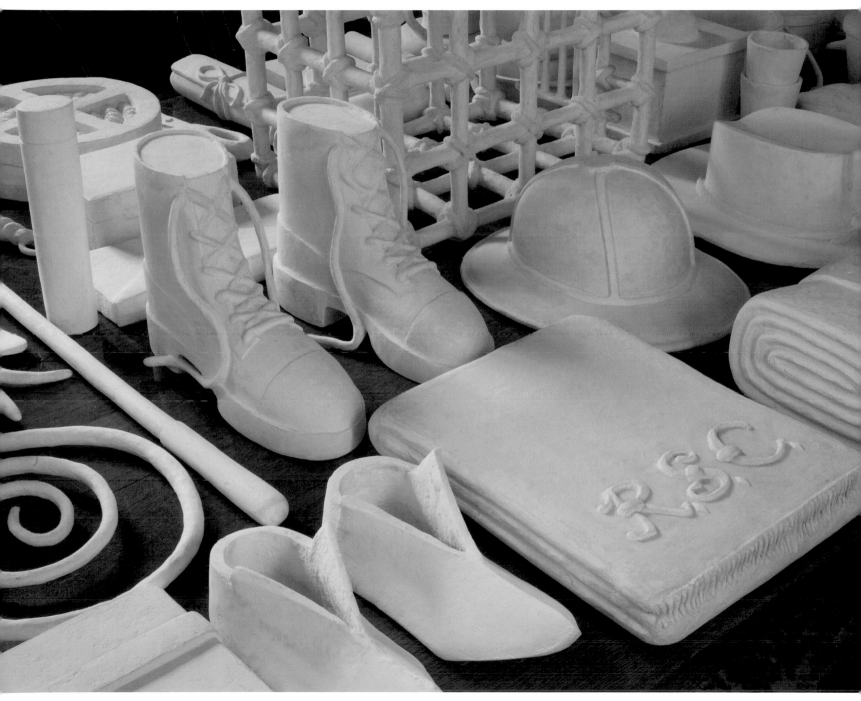

Above: Equipment—Clark Expedition (detail), 2012 (dimensions variable)
Left: Provisions and Equipment—Clark Expedition (rear left) and *Equipment—Clark Expedition (on table)*, 2012 (dimensions variable)

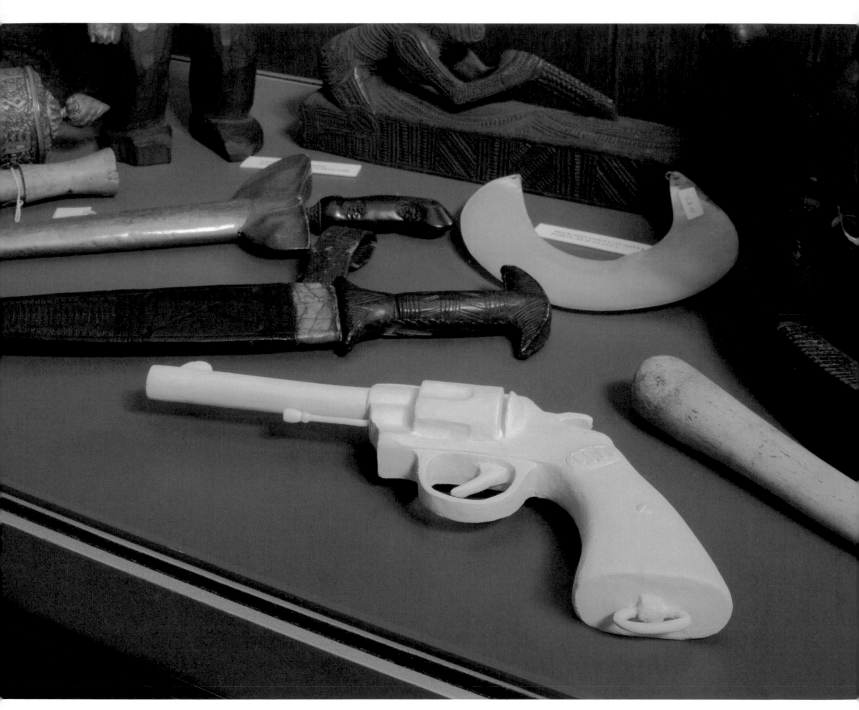

Above: Revolver of Hazrat Ali—Clark Expedition, 2012 (10 x 6 x 2 inches)
Right: Titan Moth—Clark Expedition (above left), 2012 (14 x 14 x 1 inches) and *Revolver of Hazrat Ali—Clark Expedition (on table),* 2012 (10 x 6 x 2 inches)

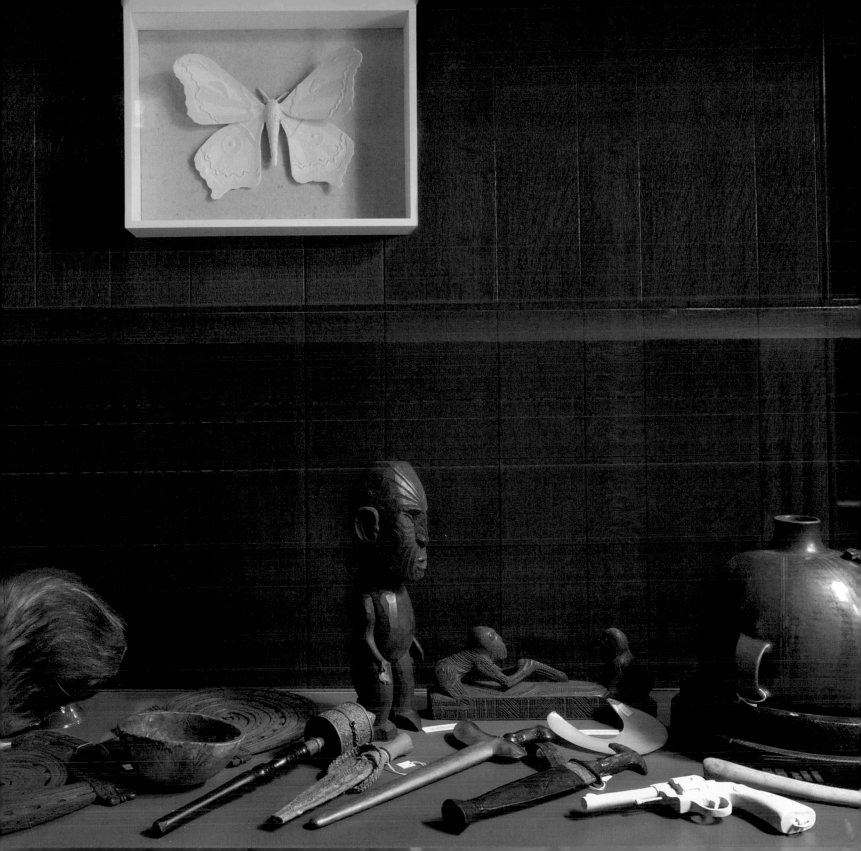

Above and left: David's Squirrel—Clark Expedition, 2012 (Synthetic plush material, 24 x 36 x 96 inches)

Above: Shên-kan Expedition Flag—Clark Expedition, 2012 (Felt and grommets, 36 x 48 inches)
Left: Titan Moth—Clark Expedition, 2012 (14 x 14 x 1 inches)

Further Reading

Clark, Robert Sterling, and Arthur de C. Sowerby. *Through Shên-kan: The Account of the Clark Expedition in North China, 1908–9.* London: T. Fisher Unwin, 1912.

Conforti, Michael, James A. Ganz, Neil Harris, Sarah Lees, and Gilbert T. Vincent. *The Clark Brothers Collect: Impressionist and Early Modern Paintings.* Williamstown, MA: Sterling and Francine Clark Art Institute, 2006.

Corrin, Lisa G. *Phantoms of the Clark Expedition: An Installation by Mark Dion.* Williamstown, MA: Sterling and Francine Clark Art Institute, 2012. Exhibition brochure.

Howells, Ginny, and Victoria Thwaites. "Revisiting Shên-kan." *Journal of the Clark Art Institute* 9 (2008): 16–19.

Juliano, Annette L. *Unearthed: Recent Archaeological Discoveries from Northern China.* Williamstown, MA: Sterling and Francine Clark Art Institute, 2012. Exhibition catalogue.

Li Ju. *Through Shên-kan: Revisiting Loess Plateau.* Translated by Zhou Chuqiao. Beijing: China Intercontinental Press, 2012.

Onians, John. "Sterling Clark in China." *Journal of the Clark Art Institute* 1 (2000): 41–47

Schutz, Lacy. "East Meets West." *Journal of the Clark Art Institute* 9 (2008): 6–15

Stevens, Keith. "Naturalist, Author, Artist, Explorer and Editor, and Almost Forgotten President: Arthur de Carle Sowerby, 1885–1954, President of the North China Branch of the Royal Asiatic Society, 1935–1940," *Journal of the Hong Kong Branch of the Royal Asiatic Society* 38 (1998): 121–36

Contributors

Thomas J. Loughman is Assistant Deputy Director at the Sterling and Francine Clark Art Institute and curator of the exhibition *Through Shên-kan: Sterling Clark in China.*

Shi Hongshuai is Associate Professor of Historical Geography at Shaanxi Normal University in Xi'an. He has written extensively on the historical geography and urban history of northwestern China during the Qing dynasty.

Li Ju is a freelance photographer and writer whose recent work engages with the historical visual record of the Great Wall and the Loess Plateau in northwestern China.

Mark Dion is an internationally recognized artist whose work examines the ways in which dominant ideologies and public institutions shape of our understanding of history, knowledge, and the natural world.

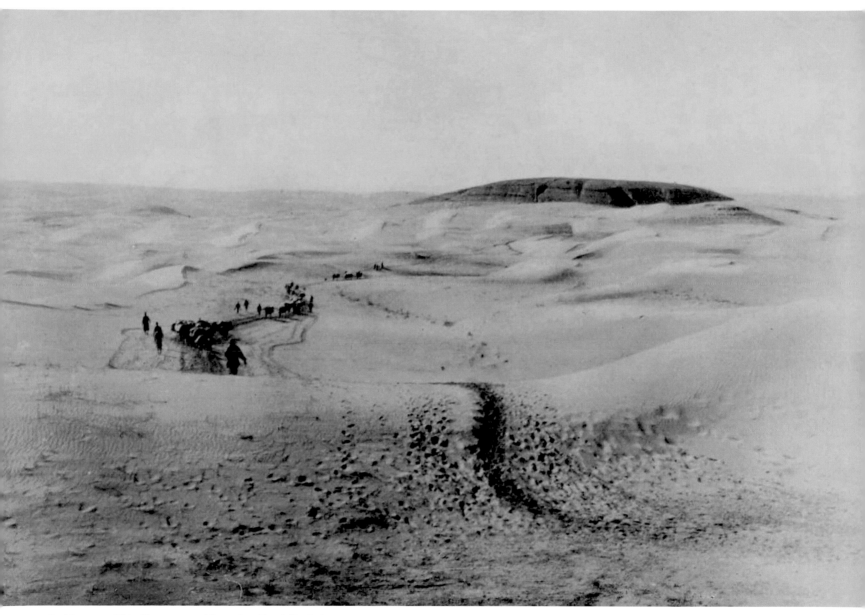

Sand dunes, east of Yulin, Shaanxi province (plate 10 from *Through Shên-kan*)

Photography Credits

Unless listed below, historical images have been reproduced from Robert Sterling Clark and Arthur de C. Sowerby, *Through Shên-kan: The Account of the Clark Expedition in North China, 1908–9* (London: T. Fisher Unwin, 1912)

Thomas J. Loughman: fig. 23

Smithsonian Institution Archives, Washington, D.C.: cover (image #2008-3129), frontispiece (image #2008-2988), figs. 8 (image #2003-19551), 10 (image #2008-3140), 12 (image #2008-3044), 14 (image #2008-3152), 17 (image #2008-2988), 19 (image #2008-3151), 26, 29 (image #2008-3149), 36 (image #2008-3130), 37 (image #2003-3137), 40 (image #2008-3131), back cover (image #2008-3140)

© Sterling and Francine Clark Art Institute, Williamstown, Mass., photo by Michael Agee: figs. 2, 9, 16, 24, 25, 28

Sterling and Francine Clark Art Institute Archives: figs. 5, 6, 7

Williams College Archives and Special Collections, Williamstown, MA: figs. 3, 4

Li Ju:
Color photographs are courtesy of Li Ju.
Black-and-white photographs are courtesy of the Smithsonian Institution Archives, Washington, D.C.: p. 52, left (image #2008-3020), p. 53, top (image #2008-3120), p. 54 (image #2008-3060), p. 56 (image #2008-2995), p. 59, top (image #2008-3139), p. 60 (image #2008-3141), p. 62 (image #2008-3029)

Mark Dion:
All works by Mark Dion are © Mark Dion Studio, courtesy Tanya Bonakdar Gallery. All photographs by Art Evans © 2012 Sterling and Francine Clark Art Institute, Williamstown, Massachusetts and Mark Dion.